IMAGES
of America

STOWE

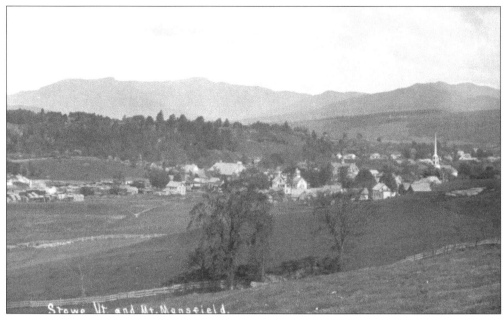

This c. 1910 view shows Stowe village as seen from Marshall's Hill, earlier known as Simmons Hill. Burt's Mill is on the left and the Community Church steeple rises on the right. Mount Mansfield towers about 7 miles away in the distance.

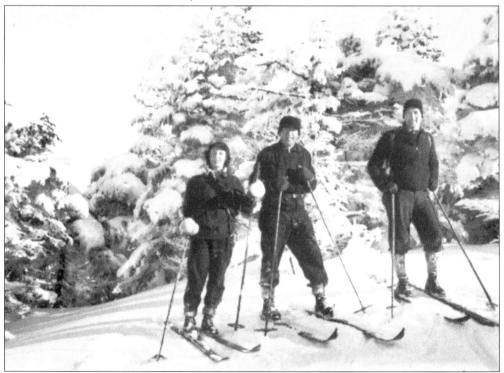

Skiing on Mount Mansfield in the 1930s was hard work! Before the installation of the rope tow in 1938, skiers needed to climb to the top before enjoying their run down the trail. This photograph was taken before the single chairlift was operating in 1940.

IMAGES
of America

STOWE

Wendy Snow Parrish

ARCADIA

First printed in 2000.

Published by Arcadia Publishing,
an imprint of Tempus Publishing, Inc.
2 Cumberland Street
Charleston, SC 29401

Printed in Great Britain.

Library of Congress Catalog Card Number: 00-106403

For all general information contact Arcadia Publishing at:
Telephone 843-853-2070
Fax 843-853-0044
E-Mail sales@arcadiapublishing.com

For customer service and orders:
Toll-Free 1-888-313-2665

Visit us on the internet at http://www.arcadiapublishing.com

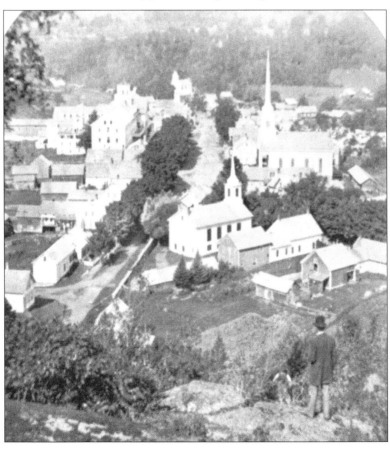

Sunset Hill, east of the village, provided a peaceful, easy getaway from the village and offered a private view of the town's activity in the 1880s.

CONTENTS

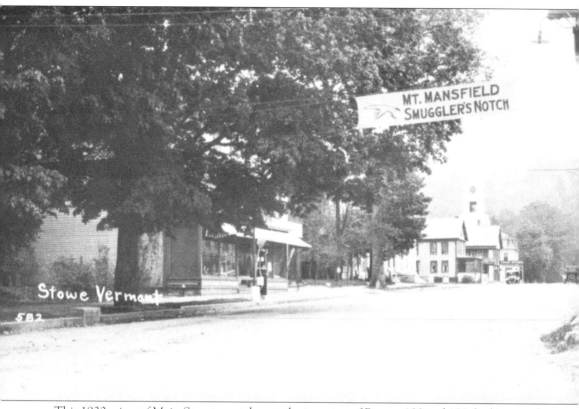

This 1920s view of Main Street was taken at the junction of Routes 100 and 108, looking north. McMahon's store, with the awning, is on the left with a gas pump near the street.

ACKNOWLEDGMENTS

When I looked through my collection to pick out interesting photographs for this book, I planned to show them to people in town who are still alive and who might remember finer details and insights than the pictures alone could ever tell. I am deeply indebted to many people for this information, some for sharing photographs for this book, including Gordon Rhodes, Edward Rhodes and the Stowe Historical Society, Hazel Poor, Gladys Knapp, Rabe Harlow, Walter Snow, Doug Snow, Sally Barrows, Bob Cochran, George Wesson, Harry Morrill, Zona Oakes, Mike Lemaire, the Davis family, Clem Curtis, Kermit Spaulding, and Robert Stafford. They have given me more than they realize. Not only have I learned more history about my town, but I have gained an appreciation for the way these people have lived and what they have shared with us. By reading this book, you will touch their lives, too, for caring about what has been shared. I would also be remiss not to acknowledge my family, including my parents and sister, whose strong interest and enthusiastic support the whole way were more than I could ever have hoped. We must also thankfully remember the photographers of the day for making these visual histories. There were many, but some of them include A.H. and A.L. Cheney, George Adams, Harry Richardson, E.T. Houston, Clifton Stafford, and N.L. Merrill.

INTRODUCTION

Stowe's history dates back almost as far as the history of the United States, to 1793 when Governor Wentworth of New Hampshire granted a charter to 64 men for the purpose of establishing the town. The first settler, Oliver Luce, arrived in 1794 and was soon followed by other settlers. By 1850, the townspeople numbered 1,771. Then, as now, the town depended on its natural surroundings.

The forest supported the settlers in the early 19th century. According to Bigelow's *History of Stowe*, by 1883 Stowe had 3 butter tub shops, 7 lumbermills, 5 shingle mills, 1 stave mill, 1 broom handle mill, 3 planing mills, and 4 sawmills. Supporting these enterprises were 9 blacksmiths, 5 shoemakers, 15 carpenters, and 5 lawyers. As forests were cleared, farming gave rise to dairying and the production of butter and cheese.

But even then, there was another highly important local industry: tourism. The earliest of settlers lacked the time or energy to enjoy the beauty of the mountain and spectacular vistas from it. Not until the early 1800s did men and women enjoy traipsing through the woods, often ruining their clothes, to climb Mount Mansfield, Vermont's highest peak, for the sheer pleasure of enjoying its beauty and the spectacular views it afforded. Thus began the tourist industry when, in 1850, Stillman Churchill traded his farm just north of Stowe village for Peter Lovejoy's house in town, turning it into the first hotel, the Mansfield House (where the Green Mountain Inn now stands). For his guests, he had the first trail to the summit of the mountain cleared. With a need for financial backing, he partnered with W.H.H. Bingham, a wealthy lawyer. Seeing the mountain's potential as a resort destination, Bingham deeded all his land above the tree line to the University of Vermont on condition that it would never be commercialized. He convinced the town to build a road halfway up the mountain and constructed there a resting place called the Half-Way House; it included a barn for the ponies and a small building for the caretaker. From this point, travelers could ride ponies up a trail to the summit. Eventually, a road suitable for carriages was built to the top.

Seeing the need for overnight accommodations, Bingham convinced the university to deed him back 20 acres; he then built the Summit House, which opened to the public in 1858. This in turn created the need for larger accommodations in town. Nine capitalists from Boston, New York, and Montreal joined him to form the Mount Mansfield Hotel Company. Their huge hotel opened with a grand ball celebration in June 1864, attracting tourists from the entire East Coast. Some families even came for the whole summer.

Rooms and amenities were added to keep up with the demand. In 1878, Col. E.C. Bailey,

from Concord, New Hampshire, bought out the stockholders to become the sole owner of the Mount Mansfield Hotel, the old Mansfield House, the Half-Way House, the Summit House, and another small accommodation, the Notch House, located in Smugglers Notch.

In 1889, the Mount Mansfield Hotel burned to the ground, but the original portion of the Mount Mansfield Hotel survived. The tourist momentum could not be stayed, however, and in 1893 the hotel remnant was purchased and renamed the Green Mount Inn. Photography helped spread the appeal of the town to new and wider audiences of vacationers. Hiking became a popular pastime; in 1920, Elihu Taft from Burlington presented to the Green Mountain Club a hut that now bears his name.

Beyond the mountain itself, tourists came to visit Smugglers Notch, a deep pass between Mount Mansfield and Sterling Mountain, formed in a great upheaval in prehistoric times. Its 1,000-foot cliffs, huge boulders, and caves have lured explorers and evoked names from inspired and imaginative lookers: the Singing Bird, Elephant's Head, the Hunter and his Dog, the Smugglers Face. Where the old Notch House used to stand is the Big Spring, where the water flows at a rate of 1,000 gallons per minute at a constant temperature of 43 degrees, supposedly fed by Sterling Pond, atop Sterling Mountain. On the other side of town is Moss Glen Falls, a long series of steep cascades and pools. The Pinnacle, a rocky knob on the western side of the Worcester Range, provides an easy hike and a spectacular view of Mount Mansfield and the village of Stowe in its valley.

As fashions have changed, Stowe has remained the center of this spectacular setting. Today, it enjoys its reputation as the "Ski Capital of the East." Befitting its origin as an outdoor-oriented town dependent on nature, skiing in Stowe began as a utilitarian method of transportation in the deep winter snows. In 1921, the Civic Club created a Washington's Birthday celebration, which began the Winter Carnival tradition, where every year about 1,000 people enjoyed ski-jumping, tobogganing, skating, and other fun winter activities.

In the early 1930s, work began toward development of the recreational skiing industry. The famous Nose Dive trail was cut by Charlie Lord, who was then in charge of the Civilian Conservation Corps (CCC) group. He was also responsible for the Bruce Trail, the first racing trail on the mountain. He surveyed the lift lines on Mount Mansfield and was in charge of the lift built in 1940. Frank Griffin, president of the Mount Mansfield Ski Club, built the first rope tow and developed the Ski School. He brought in Sepp Ruschp to manage it, and it became the model of ski schools.

As skiing increased in popularity, new needs developed: transportation and housing for the visiting skier, a ski patrol, increased capacity (more trails and lifts) on the mountain, and better trail maintenance. These fueled entrepreneurial enterprises in town, a burgeoning of hoteliers and eateries, and special events to get the tourists there. Stowe soon became a summer resort destination as well.

To accommodate residents, schools and roads were built and maintained. Social clubs became an integral part of a family's life. To celebrate the town's roots and retain a live connection to its character, in 1900 the state had established Old Home Week, which became today's yearly celebration with parades, events, and reunions.

For all that Stowe has changed, it remains true to its roots. The photographs herein offer a peek into the hard work that built Stowe, the love of town and family that sustain its people, and a Yankee spirit that has survived everything from bad weather to the toughest economic times. There is future in Stowe because of such a strong past.

One
THE TOWN

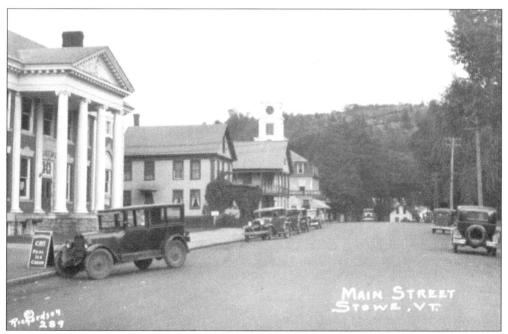

The State of Vermont allocated money to pave the road from the Stowe village line through to the Morrisville town line in 1934. Before then, Stowe had an assortment of road surfaces; some were graveled, with a few miles in cement, but the vast majority of roads were dirt. These roads were difficult to maintain. When this paving project was completed, there were hard-surfaced roads all the way from Waterbury to Morrisville. This 1930s view, looking north on Main Street, shows the Akeley Memorial Building on the left. A sign for Boardman's Café encourages locals as well as tourists to stop by.

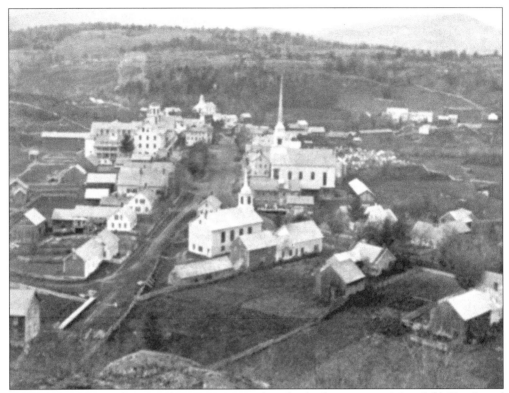

Stowe was an unusual town. The Community Church, the large Mount Mansfield Hotel, and the high school (not visible in this view) were all built around the time of the Civil War, when money was generally not spent on such a grand scale. This view, looking south from Sunset Hill, shows Stowe village in 1872.

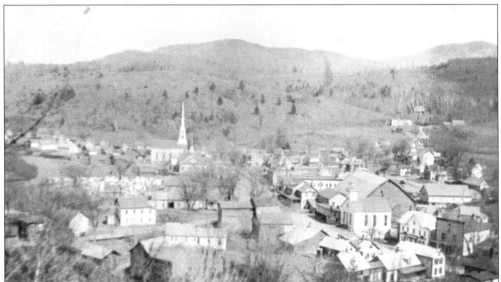

This view of Stowe was taken from Cady Hill looking across the village to Sunset Hill, c. 1906. Notice how open the hillside is. The land was heavily forested when the settlers arrived. A century of building a town and making a living in the lumber business cleared the hillsides.

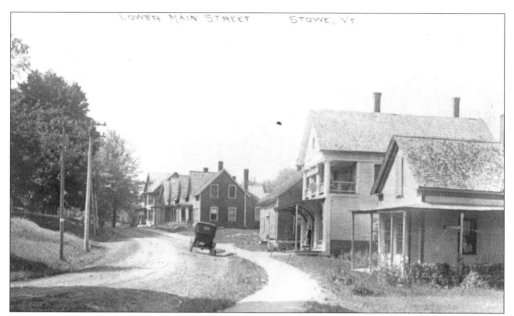

The large white building with the pillars, known as the Annex, was owned by Ben Mayo for several years in the early 1900s. Herbert, Ben's father, had a jewelry store downstairs and his mother, Fannie, ran a millinery store upstairs. The closest house was owned by Ben's brother, Earl. The Burts owned the red tenement houses (beyond the Annex) where many of their workers' families lived.

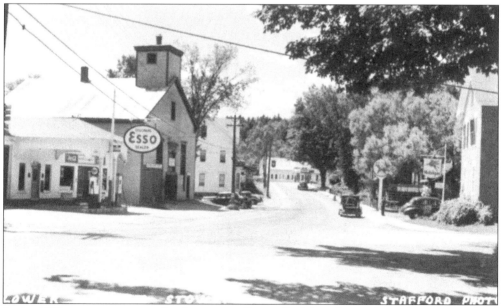

In the 1930s, gas stations were big business in Stowe. On Main Street alone, there were at least seven pumps: an Amoco pump at Stebbin's Market across from the Community Church; at Tydol across from Lackey's; at Shaw's; at the Esso station near the junction of Routes 100 and 108; Mobilgas and Texaco at Chase's Mount Mansfield Garage; Gulf at Sweet & Burt's; and a pump at McMahon's in the 1920s. Gas sold for around 20¢ a gallon.

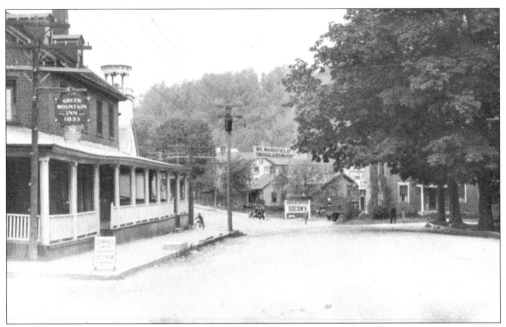

In the 1920s, one could get Turnbull's Green Mountain Ice Cream at the Green Mountain Inn and Socony gasoline at the McMahon Brothers Garage. This view looks south on Main Street past the junction of Routes 100 and 108.

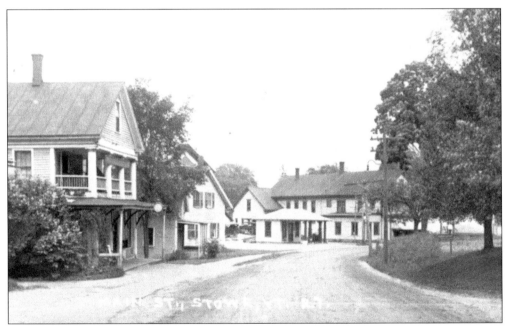

For a while in the 1920s, the Annex (with the pillars) was part of the Green Mountain Inn. The next building beyond that was the parsonage to the Methodist church, followed by Safe Anchorage, a guesthouse. The next little building, a gas station, was built on the lawn of the Methodist church, which became a garage c. 1920. The large building beyond the gas station was Pike's store with apartments upstairs.

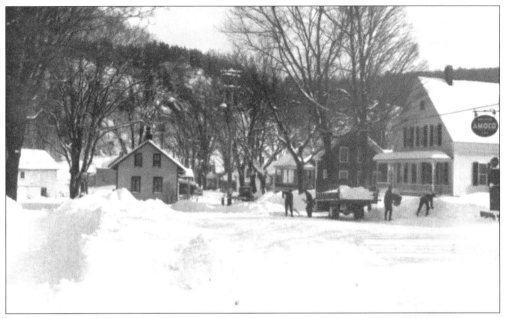

When too much snow had accumulated along the streets, a village crew would shovel it into a truck to haul it away in the 1930s. Roads were not salted except with a small amount mixed in with the sand. The roads, covered with packed snow and ice, would become quite narrow with snowbanks.

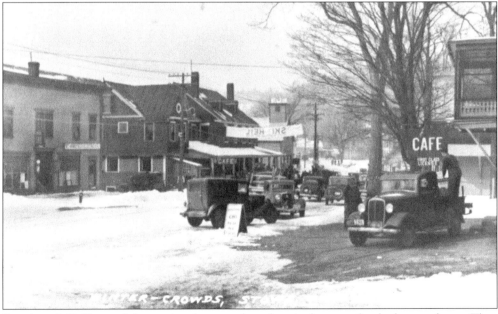

Boardman's Café served the tourists, but was also a favorite hangout for the boys and men. They sat at the counter, but ladies generally sat in another section at small tables. The Boardmans lived upstairs. This c. 1930s photograph shows a busy street with many people here to ski.

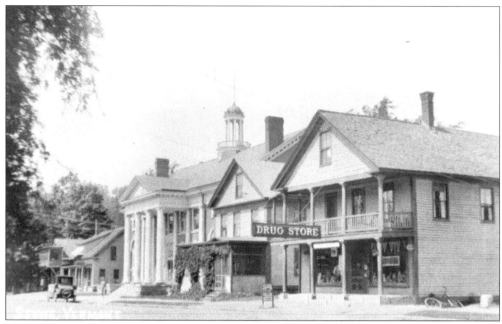

A Mrs. Brown lived in the house with the ivy. She sold it to the Staffords, who turned it into a funeral parlor. The drugstore was also owned by the Staffords and is still a family-run business. Ben Lackyard had a shoe repair and harness shop in the basement of Mrs. Brown's house. The porches were taken off both buildings in 1946.

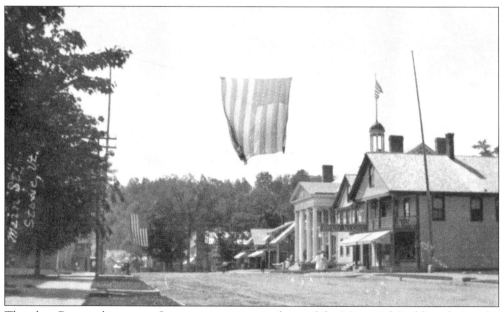

Theodore Roosevelt came to Stowe to campaign in front of the Memorial Building during the 1900 presidential race. The flag shown here now belongs to the Stowe Historical Society.

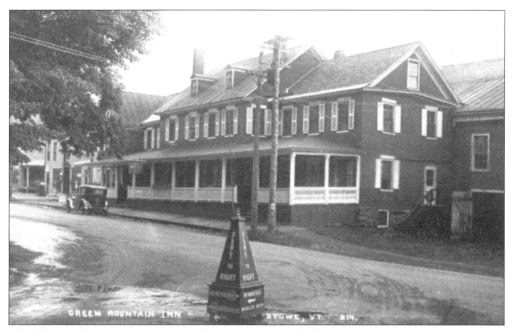

The Silent Policeman was purchased in August 1921 for $8 from the Traffic Sign and Signal Company. For more than six years, people were paid $2 a month to light it. In May 1924, it was refurbished and painted, but by c. 1930 it was no longer used.

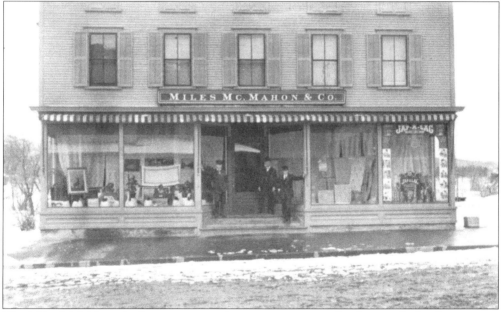

The Miles McMahon & Company general store was an agent for the Hartford Life Insurance Company, c. 1910. Notice the large picture of its symbol, the stag, in the left front window. The man on the right in the doorway is Harry Warren, an employee at the store. He always wore his felt hat and a tie.

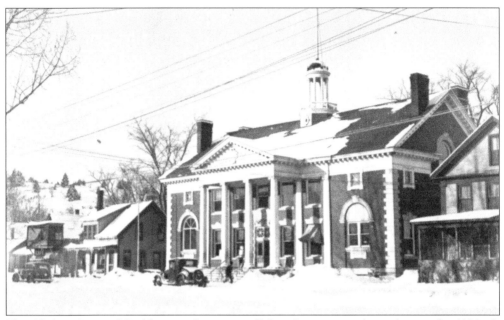

The Akeley Memorial Building, in the center of Main Street, was a busy place in the 1930s. It housed the post office, the Union Bank, and the library. Upstairs is the auditorium, and the banquet hall is in the basement.

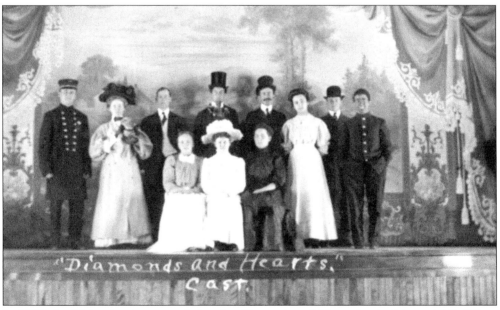

In 1908, the high school presented the play *Diamonds and Hearts* in the Memorial Building. Cast members pictured on the stage are, from left to right, as follows: (sitting) Inez Smith, Aves Vearen, and Angie Harris; (standing) Ben Robinson, Ruth McMahon, Raeburn McMahon, Lawrence Bigelow, Ben Harris, Rebecca Burt, Healy Bashaw, and Carl Darker.

On March 31, 1908, burglars broke into the post office in the Memorial Building, blew up the safe (twice!), and got off with between $500 and $600 of stamps, money orders, postal funds, cash for mailbox rentals, and about $100 in other cash. There was gunfire, but no one was hurt. Rewards were offered for the arrest of the burglars, but they were never caught. A stash of money and papers was found many years later and was thought to be the stolen goods.

The auditorium of the Memorial Building takes up the entire second floor, reached by a winding staircase at one end of the building. Seating almost 500 people, including in an upper gallery, this room has been home to town meetings, lectures, school plays, concerts, graduation, and class day exercises. In the 1930s, Etta Shackett played the piano as accompaniment to the silent movies shown there, where children were admitted at no charge.

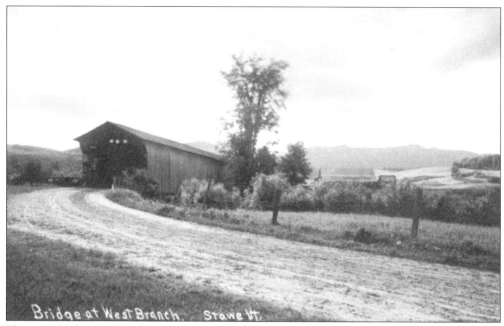

Photographed *c.* 1910 and at one time one of ten covered bridges in Stowe (only one remains now), this bridge, like its twin in Moscow, was built *c.* 1850 by John W. Smith. In 1892, a cloudburst destroyed another covered bridge just upstream where the road to Luce Hill crosses the river, leaving only this one to span the West Branch along Route 108.

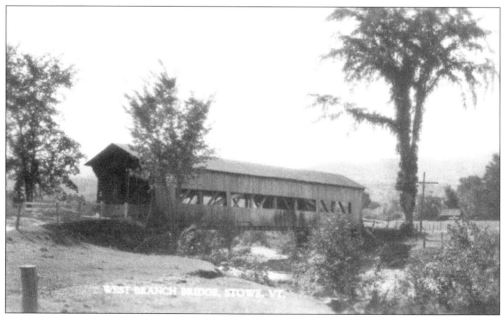

As cars became popular and speeds increased, the sides of the bridge were opened up to allow better visibility around the bend. This bridge, also called the Slayton Bridge, was replaced in 1938 to accommodate the increase in traffic due to the growing ski industry.

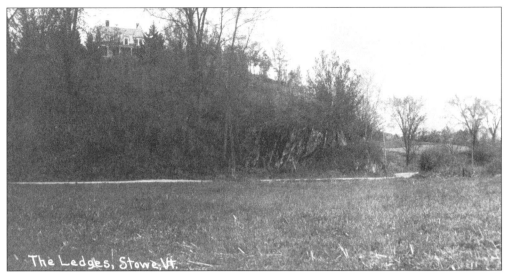

The Ledges, Stowe, Vt.

This road used to go over the hill in front of the house. In 1933, during the Great Depression, local men, including the author's grandfather, rebuilt the road around the Ledges. The men would meet at McMahon's store in the village each morning and be taken to work at the site. For three weeks that winter, the thermometer stayed at 30 degrees below zero, or colder, every morning. To drill the ledge, one man held the drill and another hit it with a big sledgehammer. The first man would give the drill a slight turn and the other would hit it again. Walter Snow partnered with Carroll Bedell. They would take turns, holding or hitting. It took all winter to blast the ledge. In the 1940s, the road was paved.

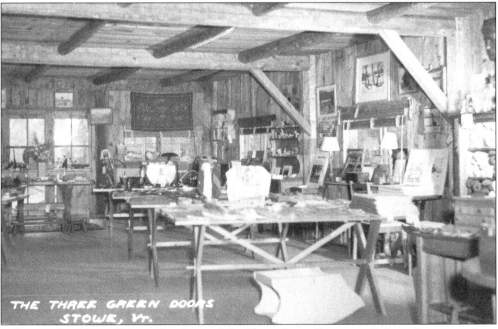

THE THREE GREEN DOORS
STOWE, VT.

Following Cecil Lang, Werner Reed owned the Three Green Doors, a gift shop where everything for sale was made in Vermont. Local boys who made things in wood shop class were able to sell their finished items here. Local artist Walton Blodgett sold his watercolors here as well.

The Palisades was a 4-acre tract of land donated to the town in 1895 by P.D. Pike for all to enjoy. There was a small building overhanging the river for dances, picnics, and family parties. This parcel of land went from behind the butter tub factory (next to Route 108) and down to the Stoware Mill. Unsuitable for much else, the land made a pretty park. The photograph dates from *c.* 1907.

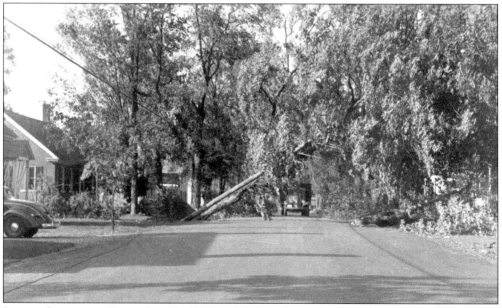

It started to rain on September 19, 1938, and did not let up for three days. During the storm, a hurricane arrived with southeastern winds up to 100 mph. The village of Stowe was hit hard; trees were torn up and chimneys were blown down. The cleanup would have taken weeks had it not been for the help of the CCC. Farmers lost many sugar maples. The estimated damage to the roads and bridges was $5,000. This picture showing Maple Street looks south. The trees have fallen onto the Bigelow home.

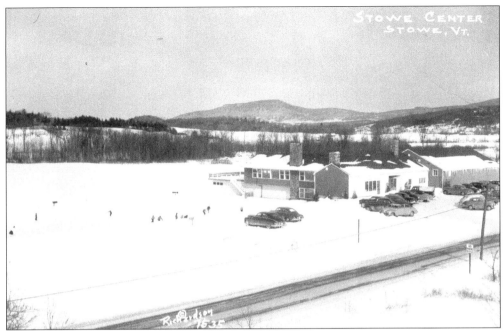

The Stowe Center, built in 1948 by John Flint and Holmes Welch, was one of the first enterprises built specifically for the entertainment of tourists and townspeople. The barnlike structure was a movie theater. There was a snack bar, a restaurant, a small gift shop, and downstairs was a bowling alley. The pool was added later. Where the two cars are parked was the first tee (the hole being down by the river) for the Stowe Country Club, then a nine-hole course.

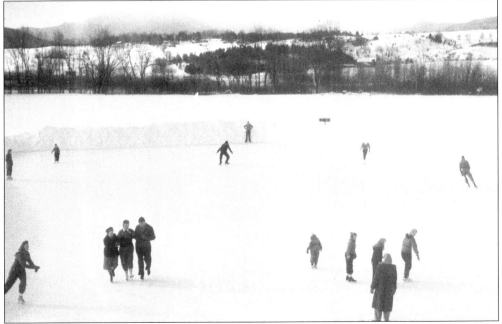

Tenley Albright, a 1956 Olympic Gold Medalist, came to Stowe that year to skate at Stowe Center as part of a nationally televised campaign for the March of Dimes. As a young girl she had polio, but was able to overcome the condition to win her medal.

21

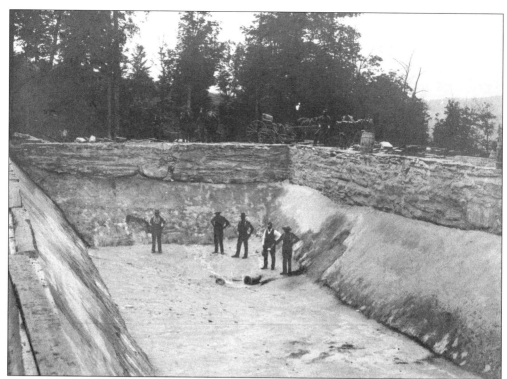

In 1904, the Village of Stowe completed the construction of the first of its two reservoirs located near the northern end of Maple Street. It is 100 feet long, 70 feet wide, and 16 feet deep. Located about 200 feet higher than the village, it holds 450,000 gallons of water supplied by numerous springs.

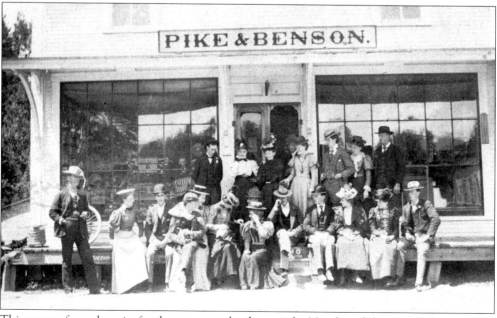

This group of people waits for the stage to take them to the Notch and the mountain for a day's outing, c. 1898.

Moss Glen Falls is another of Stowe's natural wonders. In the 1870s, there was a starch factory at the bottom of the falls and a sawmill a little farther down the brook. At the top of the falls was a log dam and a footbridge. At the bottom of the falls was a plank dam and, a little farther downstream, a cement dam. Shown to the right of the falls is the penstock held up by ladderlike bracing. The penstock was the pipe that brought the water to the generator that provided the electricity to the nearby house (see below).

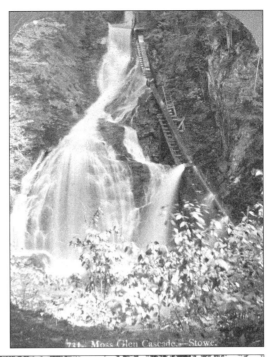

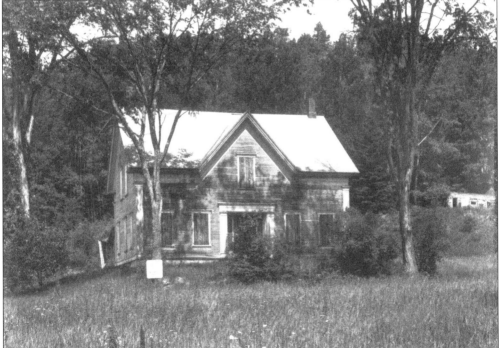

This photograph was taken in June 1932, when the house was finally abandoned. Not much has been written about the Moss Glen House, but it is generally thought that it was the starch factory owner's home and perhaps for his workers, too. Not far away is Johnnycake Flats, the site of a logging operation run by Mr. Straw. The house once had wonderful hardwood floors, making it perhaps too nice to be lodging for the help.

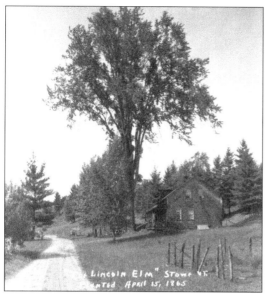

This elm tree, about 67 years old in this picture, was planted when President Lincoln was shot. At that time, the property was owned by the Straw family. The house is on the road approaching Moss Glen Falls and was owned by Levi Turner when this c. 1932 photograph was taken.

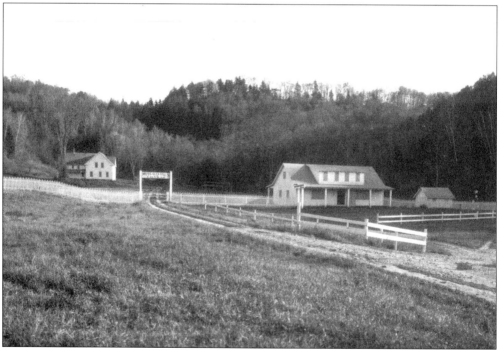

The snack bar in this 1932 photograph was quite new at the time. Since Moss Glen Falls was a tourist spot, it was thought that refreshments should be available to the sightseers. Near Mr. Straw's home was a mineral spring smelling strongly of sulfur. After World War II, Lyle Pitcher ran the snack bar, touting it as a health spa with the mineral water he bottled from the nearby spring. It had a long white marble soda fountain counter, serving the popular flavored carbonated drinks of the time. Not enough people patronized the spa, however, and it closed. The building was moved with the intention of being set up near Route 100 opposite the Benson farm, but it fell apart en route. Charlie Tinker built his house in the intended spot using the broken snack bar.

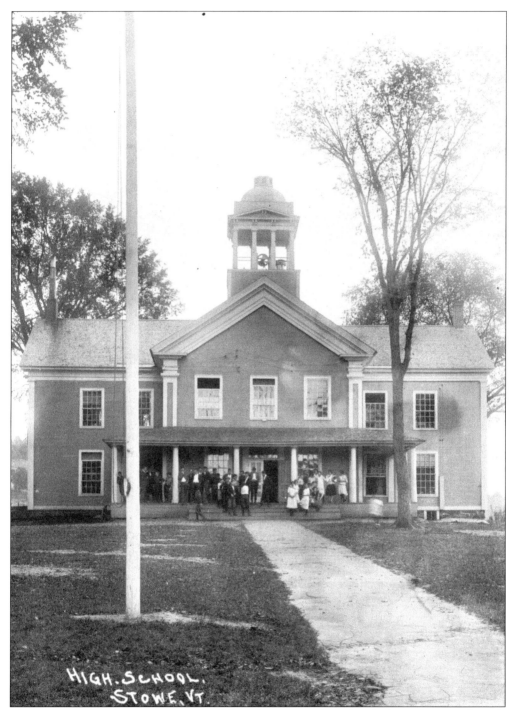

The first year of graduation at this school, built between 1861 and 1863 for grades nine through 12, had only three graduates. It has undergone many renovations since it was built, including when the Congregational Church on Maple Street was moved in 1932 to become the gymnasium; that lasted until 1954. The Class of 1972 was the last to graduate from this building. The "new" high school is on the Barrows Road.

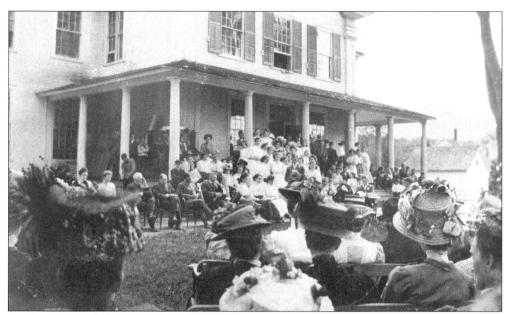

Graduation in 1909 was held outdoors after bringing over seats from the Memorial Building auditorium. That year, the baccalaureate sermon was given by Rev. J.Q. Angell. The main speaker at the graduation was Hon. Frederick G. Fleetwood, who orated about the life of Samuel de Champlain.

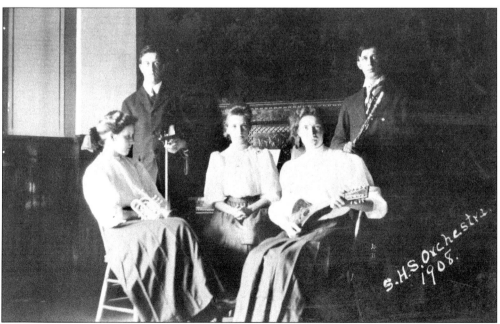

In the winter of 1908, the Stowe High School Orchestra gave a performance along with another out-of-town orchestra and Mrs. T.A. Douglass and Mr. H.W. Burnham. It was later reported that attendance had been good, resulting in revenues of about $30 toward the piano fund.

Newspaper accounts of the 1907 boys' basketball team would indicate that, for the most part, Stowe enjoyed more wins than losses. They played teams from many area towns.

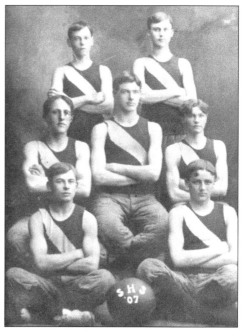

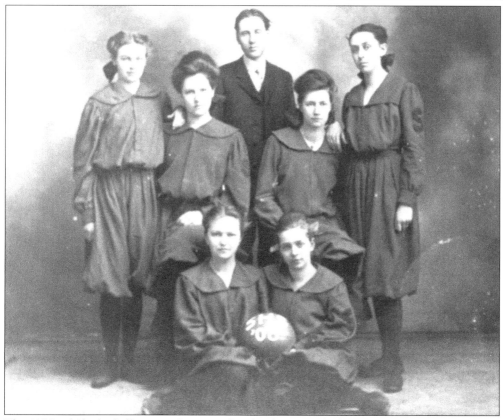

The 1906 girls' basketball team at Stowe High School was coached by a Mr. Bessey. A notation on this photograph says, "This is good of all except Mr. Bessey. It does not do him justice. M.L.W."

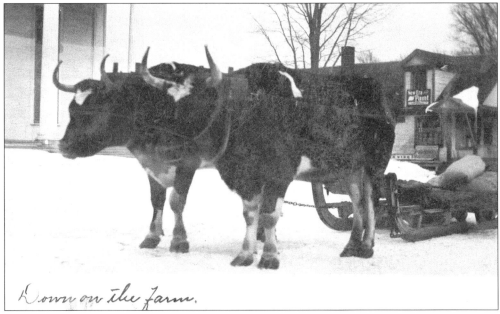

Down on the farm.

This team of oxen, shown c. 1908, probably belonged to Orson Smith from Moscow. This trip into town was to pick up wares at the tin shop and other supplies in town not available in Moscow.

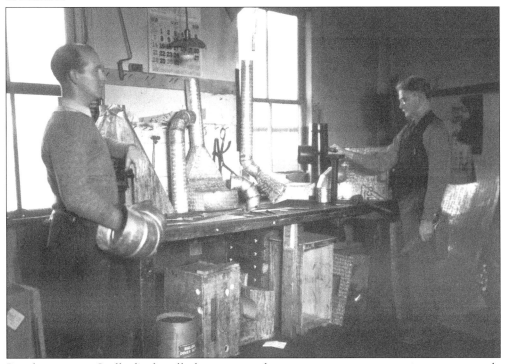

People came to Stafford's for all their tin needs: stovepipe segments, grain scoops, maple sugaring equipment and much more. It was all made on site to the customer's specifications. The calendar on the wall indicates that it is May 1939. Dalton Wells is on the left and owner Frank Stafford is on the right.

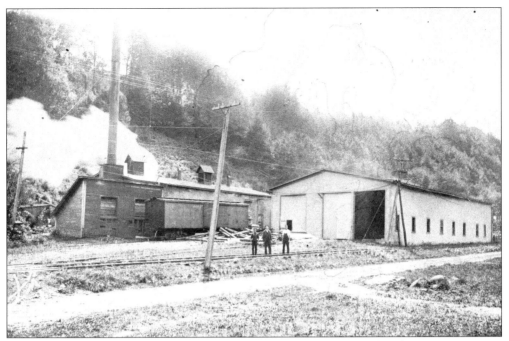

This is the trolley stop at the Moscow turnoff at Route 100. Visitors at the Pleasant View House as well as residents of the village used this stop when taking the train. Most often, Moscow residents took the River Road to reach Stowe village.

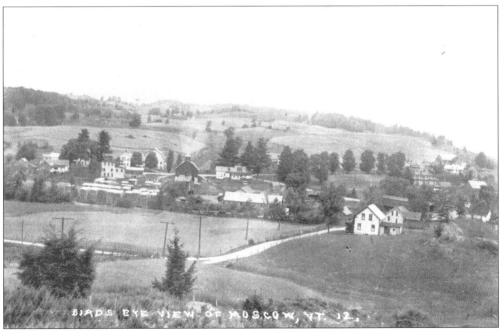

This panoramic view of Moscow was taken c. 1900, before a building from the Lake Mansfield Trout Club was relocated to the knoll in the foreground. The houses shown in the foreground were tenements for the mill workers. The stacks of lumber belong to Smith's Mill.

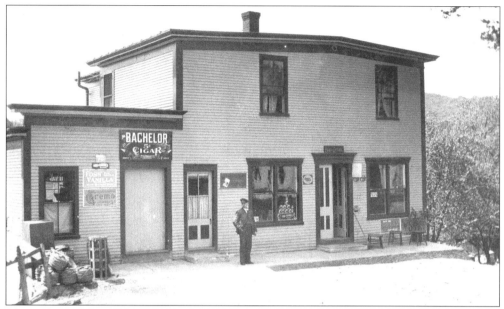

This is the Moscow General Store and Post Office, c. 1909. At that time (1909–1917), William Adams was the postmaster. As can be seen by the stools and chair to the right of the door, the store was an important meeting place for the locals where much was discussed. The signs advertise Magic Yeast, Foss' Pure Extract Vanilla, Cremo five-cent cigars, Bachelor five-cent cigars, tobacco, Arm and Hammer Soda, and Wave Line cut plug tobacco.

Alvi Smith, a very religious man, owned this farm and raised cows for milk. The barn had an unusual inside silo. Alvi kept his tractor in the barn, and when "he'd start 'er up, sparks would fly!" It is a wonder that the barn did not burn down. Following an accident, Smith had his leg amputated, a trauma that took its toll. He died some time later, and a week after his death, the barn caved in. This property later belonged to the Church family, who had previously lived across the street above the general store.

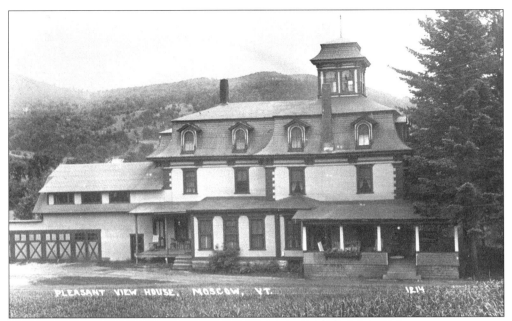

The Pleasant View House in Moscow was built *c*. 1900 and, for 23 years, was a summer resort run by Orson Smith. The Herricks bought it and continued the summer resort with a dance floor on the third story. During World War II, the tower served as Moscow's lookout to spot planes. Kids would play there, pretending that every bird was a plane. It was later renovated to accommodate skiers for several years before it burned in 1950.

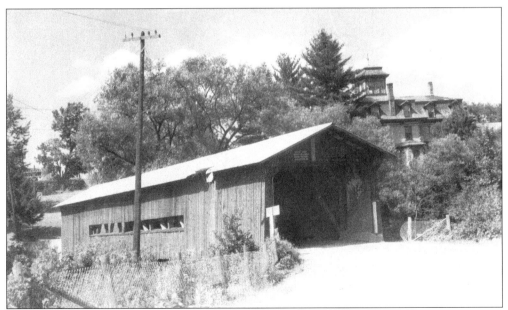

During the flood of 1927, the floor of this Moscow bridge was covered with water. The gash in the roof overhang was caused by a telephone pole that fell after the soil supporting it eroded away. Bill Phelps was in the bridge when the pole fell, nearly scaring him to death.

Baseball games became a popular Sunday pastime. In early August 1909, Moscow's team played a Sterling team and lost handily. Shown, from left to right, are George Adams Sr., Henry Baldwin, Ben Robinson, Don Robinson, Norman Peatman, Vaughn Vauksburg, Leon Russell, Charlie Marshall, and Carl Porter.

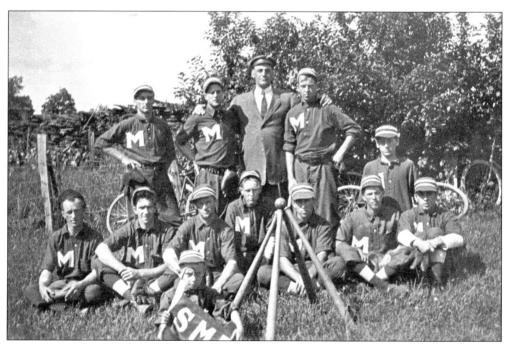

The boys at Adam's Mill had their own baseball team. The mill was owned by George Adams. In this picture, the second young man from the left sitting was his oldest son, Lester. Harry Harlow is the man in the tie. Their baseball diamond was on a flat field nearby, toward Slayton's sugarhouse. This photograph was taken c. 1920.

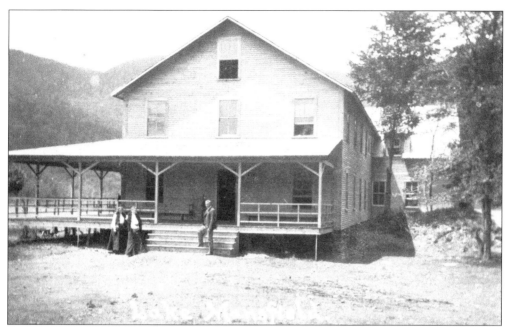

The Lake Mansfield Trout Club was a private sportsman's club that originated in 1899 with 200 shareholders. This is the clubhouse, c. 1906, after a rapid succession of additions. C.E. Burt was responsible for the damming of the Miller Brook, which then flooded Beaver Meadow to form the lake.

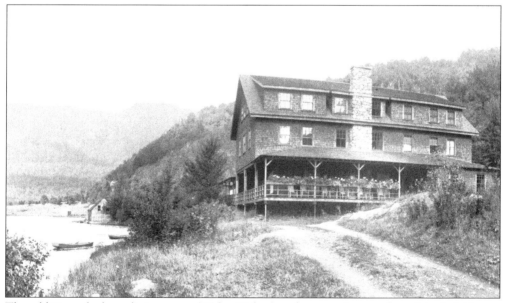

The addition of a large living room (36 by 38 feet) and renovations to the original clubhouse were completed in November 1910, making a dining room large enough to seat 100 guests at once. At that time, electricity was also added to the clubhouse as well as a boathouse and a garage. This image dates from c. 1913

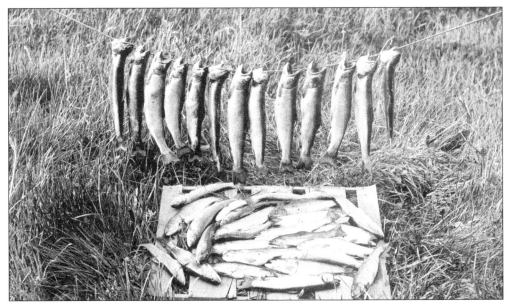

The club has always made it a priority to maintain the best fishing possible for its members. For a while, they even operated their own hatchery to stock the lake. In 1924, due to an overabundance of dace, the lake was drained. The trout were corralled at one end to facilitate removal of the unwanted fish and to dredge the lake bottom of leaves and debris. The annual dinner menu is, of course, trout. This example of a good catch was in 1907.

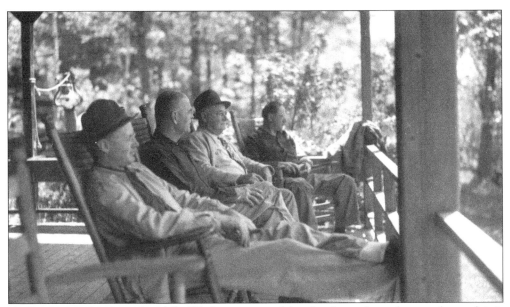

Tradition runs deeply at this club. While women and families have always been welcomed, it is foremost a men's club. With no alcohol on the menu, guests had to bring their own beverage of choice and were allowed to drink it only in the Worm Room. Here on the porch, members pass the time sharing their worldly views, discussing fishing, and generally relaxing. With hiking trails all around the hills, boats in the boathouse for use, diving boards for water play, the Trout Club was a whole world away.

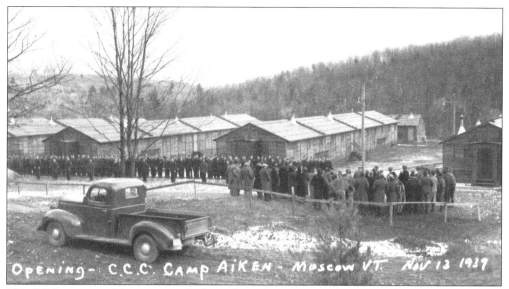

Opening - C.C.C. Camp Aiken - Moscow VT. Nov 13 1939

The CCC camps in Moscow were built in the early 1930s particularly for the Little River Dam Project nearby. This ceremony commemorates the completion of that project. The barracks pictured here were constructed so that they could be taken apart and reused. A few houses in Stowe are built from the barracks. There were also plans to construct a scenic road between Nebraska Valley and Cotton Brook, along Ricker Mountain to Bolton, but the CCC program ended before the road could come to fruition. The CCC projects brought a lot of people to Stowe, many of whom ended up spending the rest of their lives here.

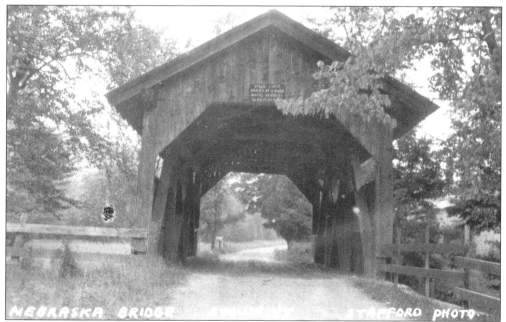

Nebraska Bridge *Stafford Photo*

Like other covered bridges in Stowe, this one in Moscow, not far from the CCC camp, was built in the mid-1800s. A fond memory was related that this bridge, in the 1940s, had several loose side boards that the local children could remove, allowing them the thrill of jumping from the bridge into the icy, mountain-fed pool below. It was more than refreshing after a hot day of haying.

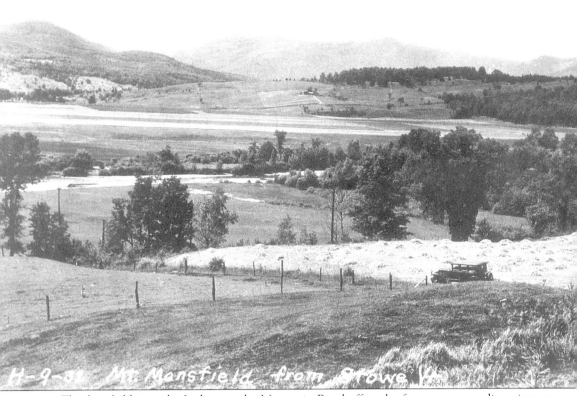

This hay field near the Ledges on the Mountain Road offers the farmer commanding views to sweeten his day of hard work, c. 1920.

Two

CELEBRATIONS
AND EVENTS

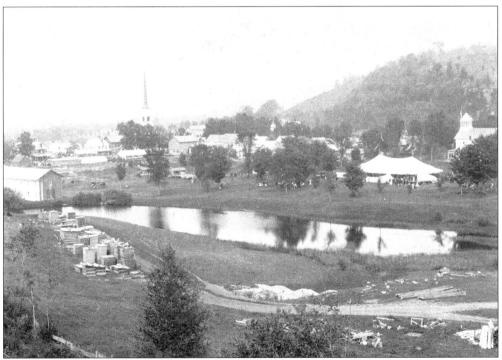

In 1894, Stowe celebrated the centennial of the arrival of its first settlers. It was a huge affair with a parade a mile long. With Burt's Mill in the foreground, you can see the tents on the back lawns of the Mount Mansfield Hotel, where many of the festivities were held.

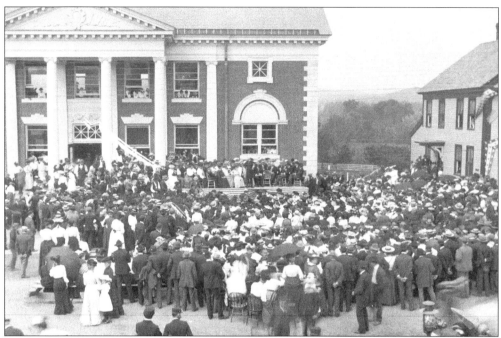

The highlight of Old Home Week, August 1903, was the dedication of the new Akeley Memorial Building, a gift to Stowe by H.C. Akeley, who grew up in Stowe but was later a prominent citizen of Minneapolis. His vision was to provide a monument to memorialize the dead, but would also be of use to the living. The Memorial Building is located on Main Street.

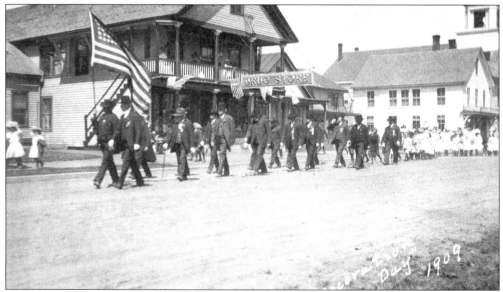

Decoration Day 1909 brought out the area's Civil War veterans. Among them, the man with the cane behind the flag carrier, is Sam Spaulding. He was an Abnaki Indian and was paid $60 to go into the war for a man from Monroe, New York. He was part of the Battle of Bull Run (and many other well-known battles for which he received medals) and was present when General Lee surrendered. Upon his return to Stowe, he owned the Spaulding block, the now vacant parcel on Main Street between the Community Church and Lackey's Store.

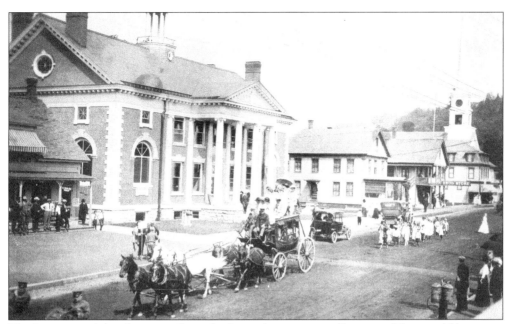

The Burts owned the electric trolley, which put the stage out of business. They would bring out the old stage for the many Old Home Day parades. The stage is now in a museum in Chicago.

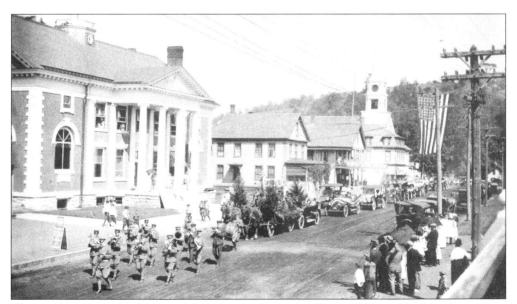

This *c.* 1910 view of a Memorial Day parade shows the Stowe Military Band leading a float sponsored by the Campfire Girls.

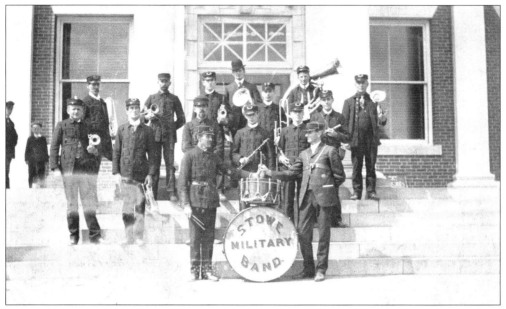

The Stowe Military Band at one time had more than 50 members. They played at Memorial Day, Fourth of July, and Old Home Week parades as well as the Winter Carnival's debut in 1921. This c. 1926 photograph shows Howard Shaw on the left with his E-flat coronet, along with Burt Godfrey, Clyde Nelson with a coronet, Norman Clark, Howard Smith, Clayton Morrill, Hollis Stockman, and Frank Stafford with the saxophone. Farthest to the right is Harry Burnham with a French horn.

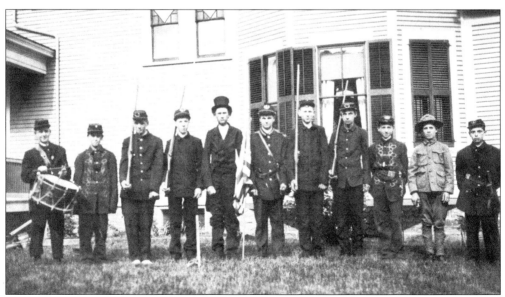

These school-aged boys are dressed for a Memorial Day parade. The tallest one got to be Mr. Lincoln. The second boy from the right is wearing a World War I uniform.

The Mansfield camp of the Modern Woodmen of America (MWA) showed this float in Woodmen's Field Day in Morrisville. The event drew a large crowd that day. The parade included the band followed by MWA camps from Wolcott, Stowe, Hardwick, Waterbury, and Morrisville—all in uniform. Stowe won a cup for their show.

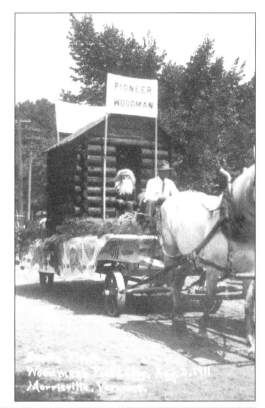

Following the Woodmen's Field Day in Morrisville in August 1911, the Mansfield camp of the MWA show off their prize in front of the Akeley Memorial Building.

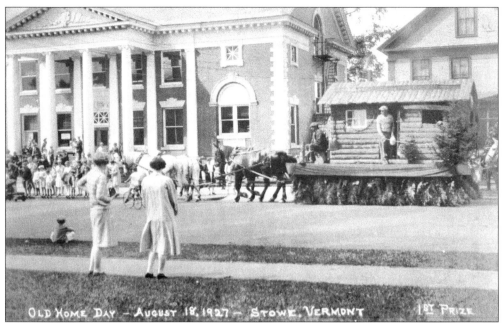

OLD HOME DAY – AUGUST 18, 1927 – STOWE, VERMONT 1ST PRIZE

This float presented by the C.E. and F.O. Burt Company won first prize. It represented a lumber camp complete with the cook and his dishpan at the door. Craig Burt kept the cabin in his back yard for several years after the parade.

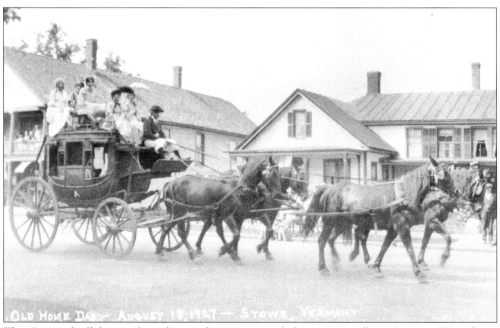

OLD HOME DAY – AUGUST 18, 1927 – STOWE, VERMONT

This Concord tallyho coach, earlier used as a stagecoach from Morrisville to Stowe to Waterbury, won second prize in the street parade. Owned in Morrisville, it was sponsored for this event by members of the Jedidiah Hyde Chapter of the Daughters of the American Revolution (DAR).

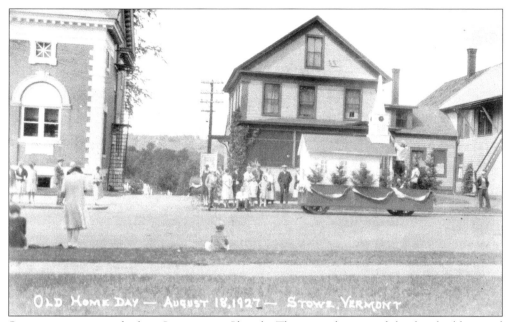

Stowe was very proud of its Community Church. This reproduction of the fine building and beautiful steeple won third place in the Old Home Day parade.

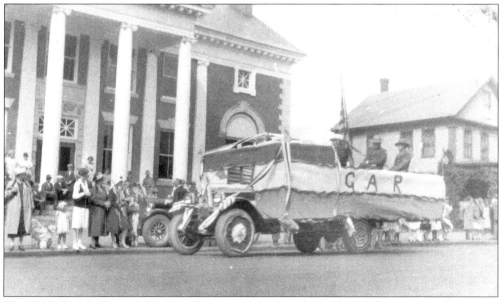

The H.H. Smith Post of the Grand Army of the Republic (GAR) float was used in many parades to march down the main street. This post, organized in 1869, was named in honor of Sgt. Maj. Henry Smith, who was killed in the battle at Gettysburg. He was the first local to die in action during the Civil War. He had worked for Mr. Pike. By 1926, most members of this group had passed away, resulting in the end of the organization in Stowe.

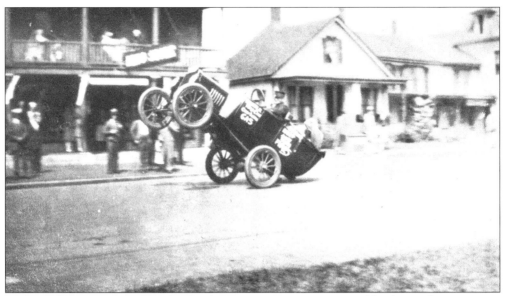

In the Old Home Day parade of 1927, the spectators were entertained by this trick car carrying the message, "Beware as this car contains gas. Always keep away from fires."

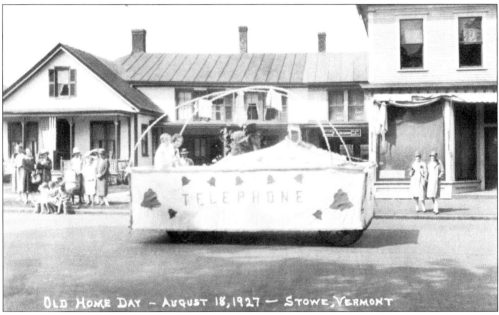

OLD HOME DAY – AUGUST 18, 1927 – STOWE, VERMONT

In the company of other floats from the Green Mount Inn, the Lodge, McMahon & Company, the Stowe Cash Market, the Mount Mansfield Creamery, McMahon Brothers Garage, and still many more, was the Stowe Central Telephone office's float. While there had been rudimentary telephone service in town for several years, it was in just the previous year that New England Telephone had taken over the phone system. Doris Moulton and Kathleen Ellsworth are riding in the back. Annabelle Moriarty was one of the first operators when it was located in the Straw house next to the Masonic Building on Main Street.

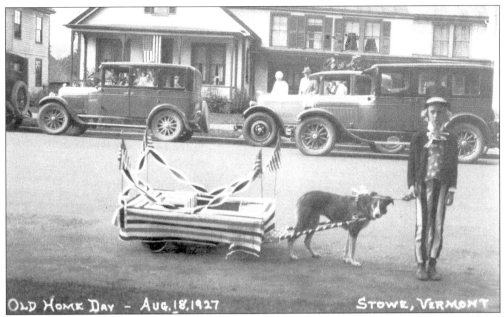

In the decorated bicycles division of the parade, first place went to Van Ness Ayers and his trained dog.

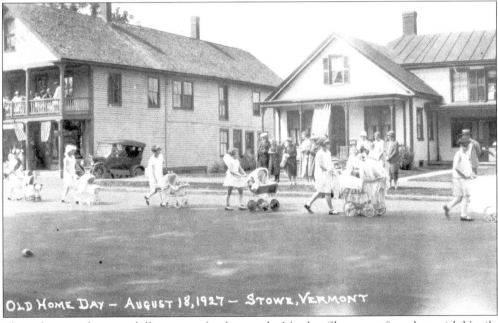

The girls got to decorate doll carriages for the parade. Marilyn Shaw won first place with Vanila Magoon and Thelma Horner placing second and third, respectively. Arlene McCuen charmed the crowd by having a real baby in her carriage! Four-month-old Ardith Gale was the youngest parade participant.

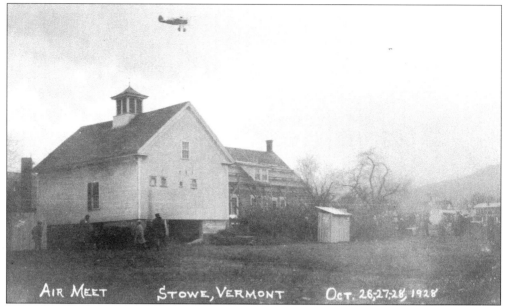

AIR MEET STOWE, VERMONT Oct. 26, 27, 28, 1928

The fall of 1928 brought a new event, the Air Meet, to the Gale farm in Stowe. Emile Lemaire owned the farm next-door and got "rich" one day by charging spectators 50¢ a car for parking in his field. He earned enough money to pay the whole year's taxes that fall. The Air Meet was a big event that drew at least 1,000 people, who got to see the first airplane land in Stowe. Plane rides were offered to the daring for only a couple of dollars.

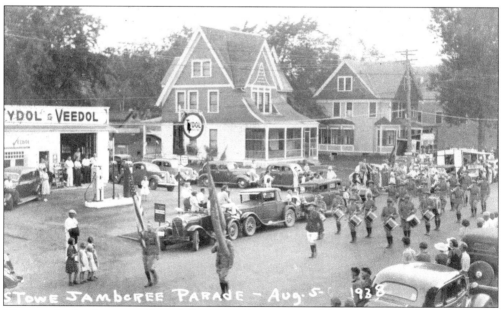

STOWE JAMBOREE PARADE - Aug. 5 - 1938

The two-day Jamboree was Stowe's largest and most successful celebration to date; the parade was the show-stopper. There was over a mile of old vintage vehicles either pulled or driven, many floats, bands and drum corps, along with commercial entries. Burlington's American Legion Drum and Bugle Corps, the new state champions, was the crowd's favorite that summer.

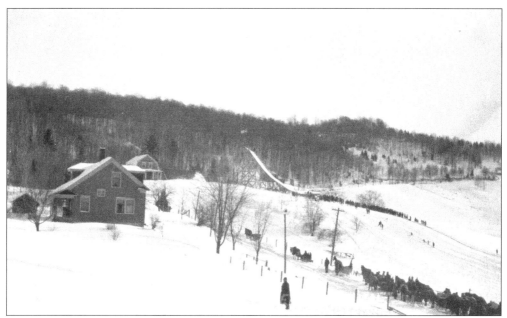

The first annual Winter Carnival was held February 23, 1921. It drew a crowd of 1,000 people to Stowe from University of Vermont (UVM), Norwich University, Dartmouth College, and towns nearby. Mr. Edlund of UVM won the ski-jumping event, making a distance of 62 feet. There were contests in snow-shoeing, tobogganing, and skiing including a ski-dash, and a 220-yard dash. The United Ladies Aid societies earned $97 from serving dinners. The day ended with a big dance. Houses and stores were decorated for the event.

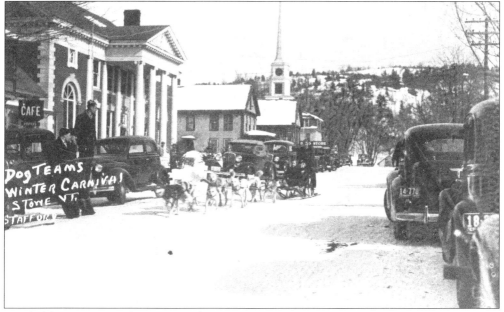

Dogsledding was a popular event in the Winter Carnivals of the 1930s.

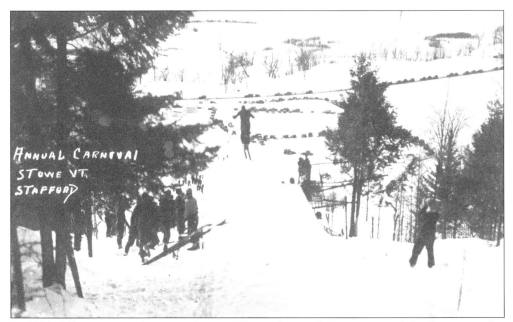

In 1932, following several years without a Winter Carnival, Stowe revived the festivities, this time on the hill behind Quincy Magoon's farm on Route 100, just north of the village. This ski jump was 300 feet long.

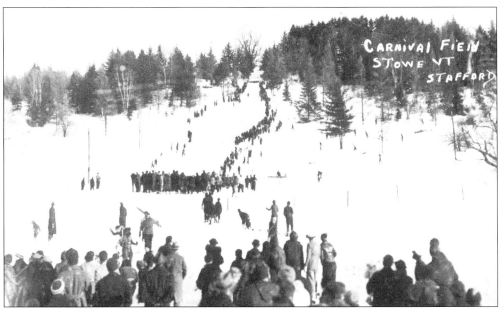

Skiers like Carlisle McMahon, a talented jumper from Stowe, climbed up a big tower to the jump and steep run-off. It was exciting to watch the skiers soar through the air.

Three

THE PEOPLE

Elsie Stebbins and her two friends, standing in front of the Asa Raymond house (now the Swisspot Building), sent this postcard of themselves to their friend Harry Warren. Harry was in Burlington at the Mary Fletcher Hospital having his appendix removed. He missed ten weeks of work at Miles McMahon & Company in the summer of 1909.

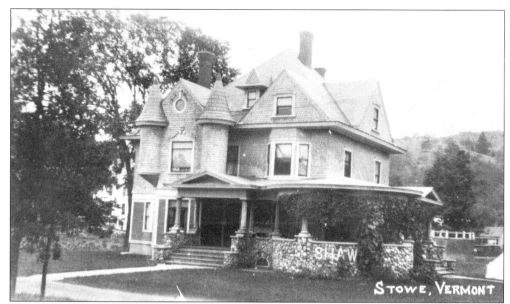

This village home was one of Stowe's finer examples of architecture. It was built between 1906 and 1908 by Howard Shaw Sr., who worked at the mill in Sterling. He hand-selected wood so that the house could be trimmed in a variety of species: red birch in the front parlor and foyer, two rooms in bird's-eye maple, and the dining room with a built in sideboard with curved glass in maple. Throughout the house were heavy moldings and chair or plate rails. Rocks for the porch were gathered from around town on Sunday horse and buggy rides. The building was torn down *c.* 1960 to make room for a bank and post office.

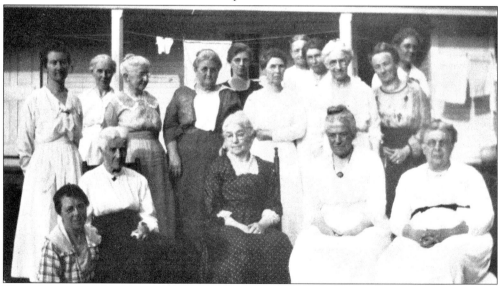

These ladies, in all likelihood, have gathered for a social club meeting of some sort. There were many opportunities for service and social gatherings. Shown *c.* 1920 are, from left to right, the following: (front row) Grace Gale, Betsy Slayton, Elvia Gale, Grace Bigelow, and Carrie Bigelow Straw; (back row) Jennie Gale, Annie Bigelow, Mary Bigelow, Addie Magoon, Mary Gale Billings, Florence Maynard, Cynthia McAllister, Susie Bigelow, Addie Bigelow, Cora Sanborn, and one unidentified person.

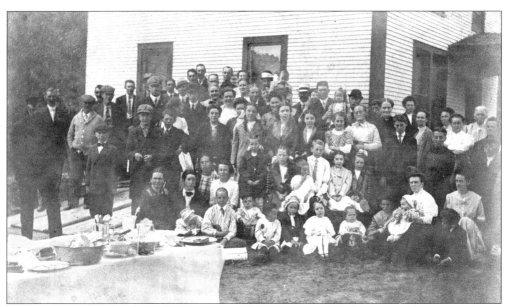

The Ayers family had a large family reunion almost every year. This one, in August 1913, was held at Herbert Cleveland's home on Barrows Road in Moscow.

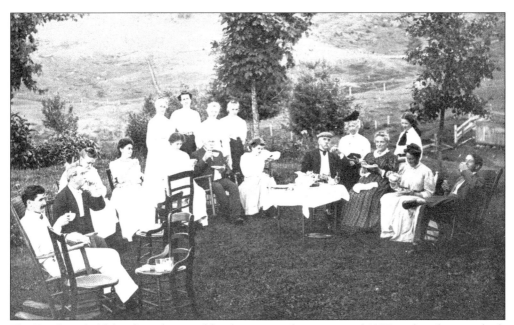

The Bigelows held family gatherings like this one in the summer of 1907 at their home, which was known as the Ledges. Included in this group are Uncle Ned, Aunt Celeste, Grace and Lawrence, Mary, Addie, Myra, Annie, Miss Baldwin, and Mr. Clarke.

The girls in this picture, standing in front of one of the three new Victorians on Main Street (pictured below), wrote on the card, "Dear Aunt, We just got over the measles. How are all the folks? Does this look natural? Mama is going to Wolcott soon. As ever, Mary and Elma. 6/25/09."

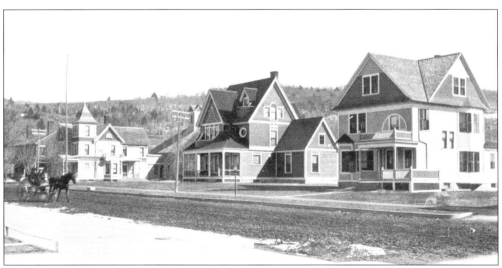

After the great fire of the Mount Mansfield Hotel, these three homes were built on Main Street. The house on the left, known as the Carriage House, belonged to Arba Pike. The middle house is known as the Shaw home, and on the right is the Kimball house, which became the Newtons' home. The back foundations of these homes are very near the front foundation of the old Mount Mansfield Hotel.

Lottie and her friend pose on the footbridge at Pike's Mill in 1908. The workers mostly used this bridge as a shortcut from the village to their job at the mill.

According to the message on this postcard sent on May 24, 1918, Lassie's five puppies are doing well, "sleek and healthy, having eyes open and beginning to bark when talked to." Every farm had at least one dog to help with the cows.

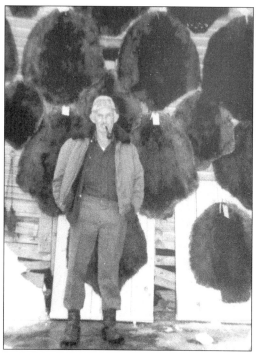

This *c.* 1948 photograph shows Walter Snow Sr. during his first year of beaver trapping. The game warden would come by to tag the pelts, enabling the state to monitor the beaver kill. Fur buyers were not supposed to buy a pelt without a tag. At this time, a blanket beaver brought between $75 and $80.

This is the home of B.H. Luce in Stowe Hollow, *c.* 1890. It is a plank house where the walls are made of stacked lumber, making it very solid. The planks came from the sawmill just down the road at "Emily's Bridge." It is now known as the Peterson house, after it had been owned for a long time by Edwin Peterson.

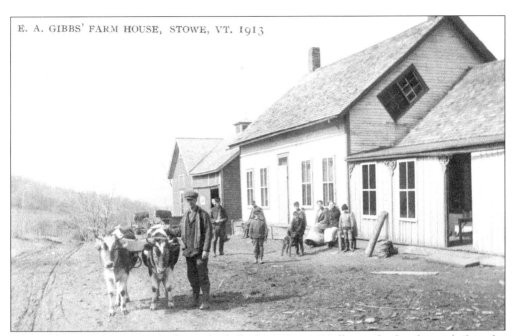

Mr. Gibbs's farmhouse was high up the hillside in Stowe Hollow—the last house before the road headed over the hill to Waterbury. The house remains, but the barns are gone.

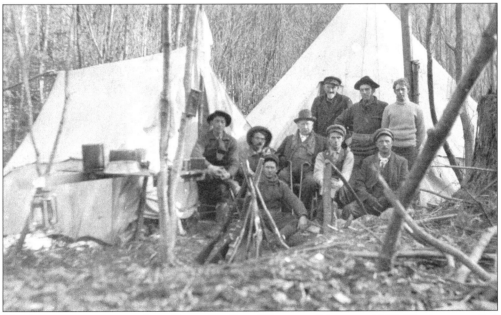

This hunting party camped on Cherry Knoll on Worcester Mount *c.* 1908. The horses pulled the wagon of supplies as far into the woods as possible. The men pulled the wagon the rest of the way to the campsite. The first deer shot in Stowe was in 1900. In 1908, Stowe hunters had killed 23 deer. Just two years later, almost 400 hunting licenses were granted, resulting in 60 to 70 deer being killed.

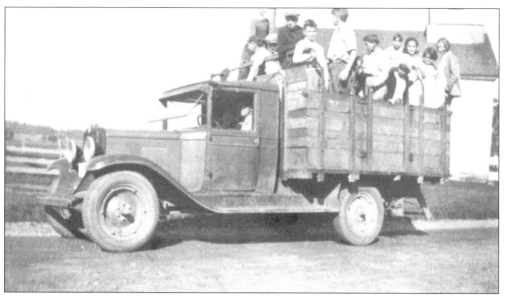

Carroll Pike drove his truck full of children to the school in Stowe village. In the winter, he put a canvas over the top. Hazel Sanborn (Poor) was in the seventh grade at the time of this 1928 photograph. She had gone to grades one through six at what is now the Episcopal church. She lived in the brick house near the bottom of Luce Hill and had to walk to the main road to catch this "bus."

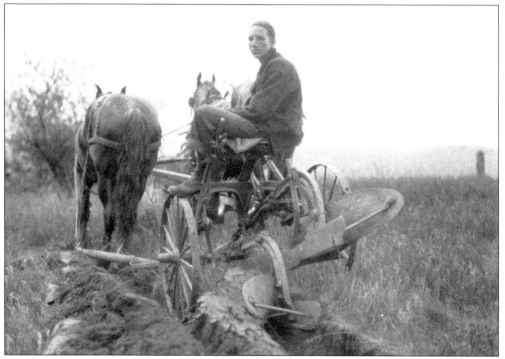

In this *c.* 1917 photograph, John Poor poses with his team and their handiwork. His family's farm was on Route 108. Most of the farms, including this one, were eventually converted from farms to lodging or restaurants for the tourists.

The Poor family owned this farm and Vermont's "Perfect Maple Tree" on Route 108 near the West Branch cemetery. The bell (beyond the tree on the left) came from the old fire station near the junction of Routes 100 and 108 in the village.

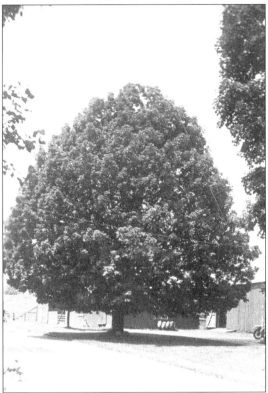

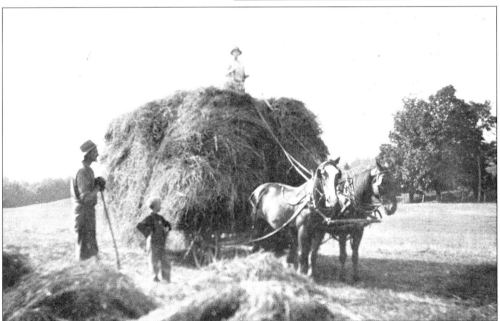

In the early 20th century, guests at Stowe often stayed in farmhouses. Sometimes the guests, such as the little boy in this picture, liked to experience the farm and chores. The Poor's hay field was across the road from the farm where motels now stand. Mark Poor drives the horses from the top of the hay. John, the oldest son, is to the left.

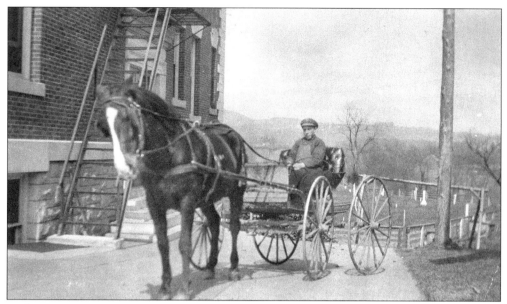

Willie Morrill of Waterbury and his horse, Old Mike, pose in the driveway next to the Memorial Building. It appears that he is in town on business, *c.* 1912.

Madame Maltzan visited Mount Mansfield from Germany for several summers (*c.* 1870) when Walter and Grace Churchill owned and operated the Summit House. She is shown near the hotel sitting at a little bower that she built.

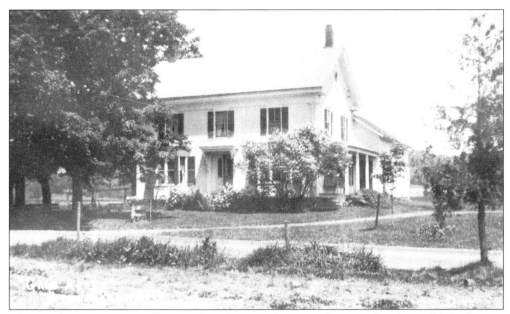

This fine home was originally owned in the 1870s by R.D. Slayton, who then sold the farm to Angus and Florence Gale. In the spring of 1928, the Lemaire family arrived from Canada and bought the house and about 200 acres. At that time, the house consisted of three apartments: one for the parents and one for each of the two sons and their wives. The house is now Whiskers Restaurant.

Every parade and celebratory event had a committee. This group, including Healy Bashaw, Gale Shaw, Fred McCarthy, and Carroll Pike pose for their recognition. This was probably a Memorial Day in the 1940s.

This is the home of Charles Eddy on Route 108 in 1906. Eddy operated the creamery seen beyond his home, in the early 1900s until he went bankrupt. In 1914, the creamery was purchased by a group of people, changing the name to the Mount Mansfield Co-Operative Creamery. The fine brick home later became the Elmwood Lodge under the ownership of Phil Edwards, followed by the Yodler with Bob Justice. It is now the Inn at Little River.

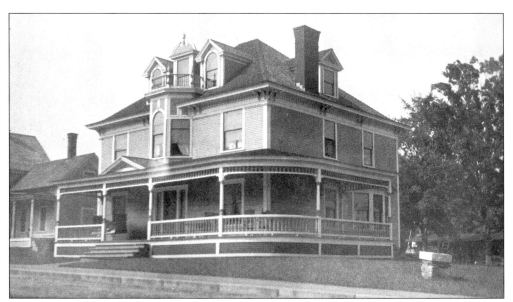

The home of Charles E. Burt, a prominent businessman in Stowe, is located on Pond Street. He began his career in the stable and livery business. Then, in partnership with his brother Frank, he went into the lumber business only to amass the largest timber holdings in town.

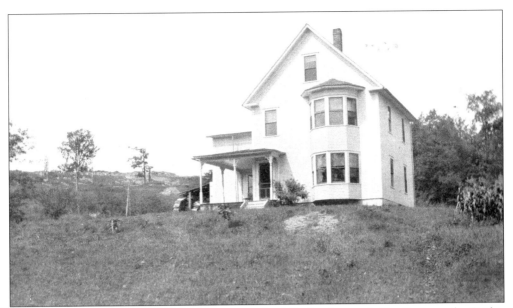

Everett "Pop" Hillman lived in this house on the hillside about a half mile from the Bridge Street bridge in the village. He kept a shop in his barn, where he did woodworking projects for customers. This home is now a restaurant.

In Moscow, Fred Smith's home overlooked his mill property. When the demand for butter tubs waned in the 1930s, Smith rebounded with his manufacturing of wooden package handles. He had to design some of the machinery required to making his handles. Stores would buy his handles, wrap a paper label with the store name on it around the handle, and give it to the customer to use for carrying their parcels home. The falls in Moscow are named for Smith.

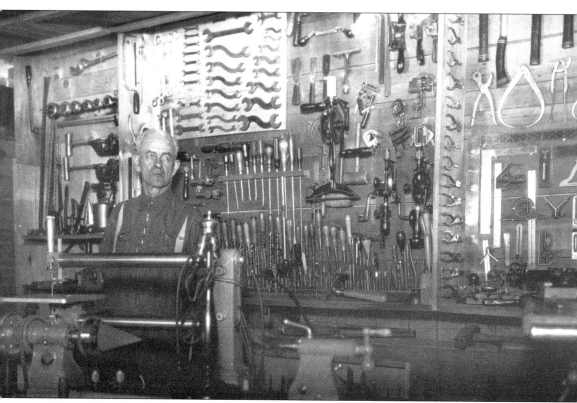

Howard Smith, the shop teacher at Stowe High School, poses in his classroom with his vast array of tools in 1940. He was a carpenter by trade and lived on Maple Street.

Four

THE WORK

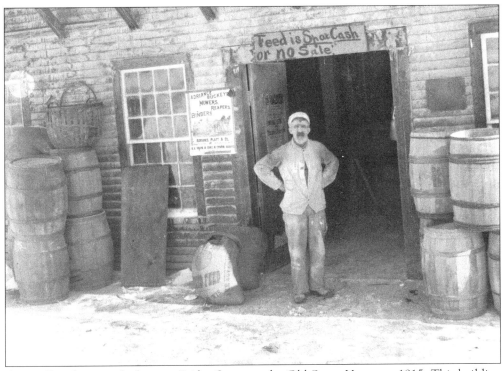

George Burnham tends shop on Bridge Street at the Old Sugar House, c. 1915. This building is no longer standing. The sign indicates a Yankee's stand on doing business: "Feed is Spot Cash or No Sale."

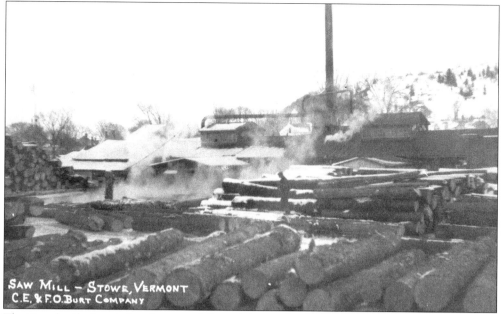

The Burt family founded and operated Stowe's largest lumber business beginning in the 1840s. The expansive holdings included interests in smaller logging enterprises as well as a store and housing for the employees. Their facility was a short walk behind the Green Mount Inn, right in the village.

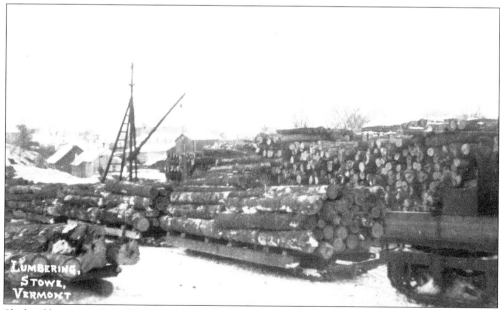

Skids of logs were brought from the many logging camps around the town and far back in the hills. These "trains" were pulled by teams of oxen and later by a huge tractor. To turn the corner off Main Street, each skid needed to be unhitched and taken separately to the mill just down the street.

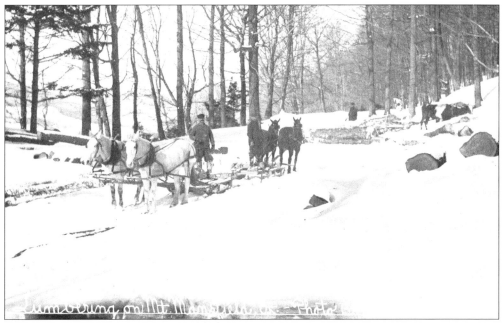

This is a typical logging scene, most likely near Barnes Camp.

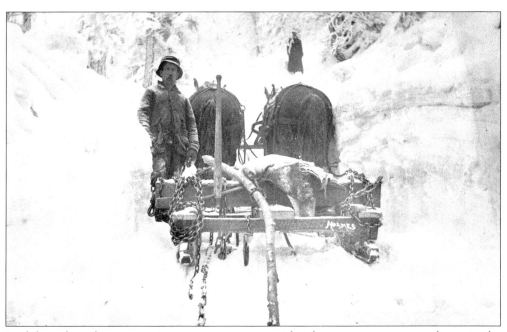

Look how deep the snow is! Logging was never considered an easy way to earn a living in the early 1900s.

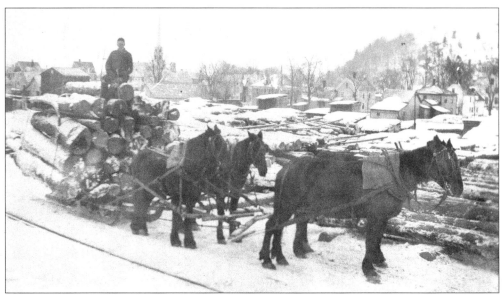

Pliny Vondle draws logs out of Sterling to bring them to Burt's Mill in the center of town, *c.* 1911.

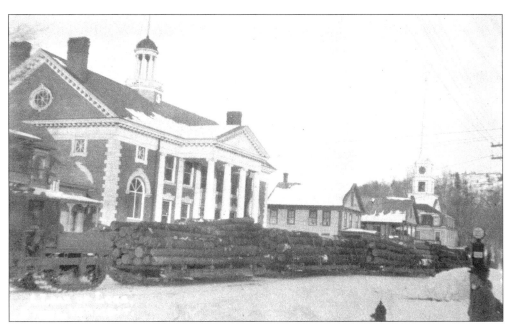

A load of logs comes into the mill from the Moss Glen area. The tractor made the local children unhappy because it would ruin the sledding on the roads by tearing up the hard-packed snow. Windows would rattle as the tractor and its load rumbled by.

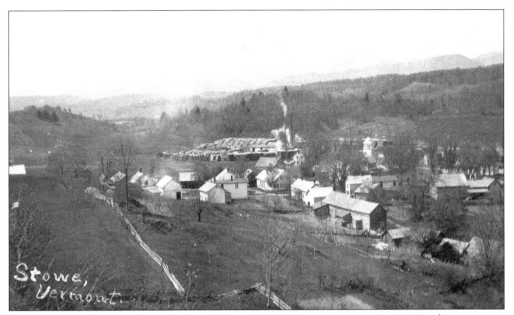

From across village rooftops is the C.E. and F.O. Burt company. In 1895, the company consolidated its numerous operations to the village, where all manner of lumber was manufactured as well as clapboards, box shooks, butter boxes, and piano stock. The company operated well into the 1960s.

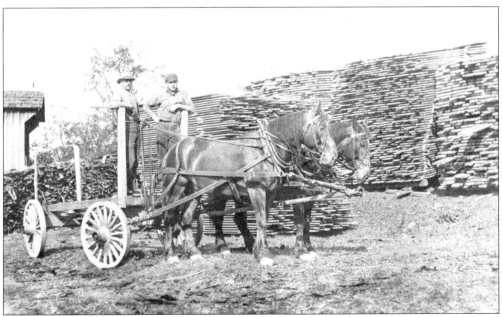

Stacks of lumber await further manufacturing into butter tubs and boxes at G.M. Culver's (later Pike's) mill at the Lower Village in the early 1900s.

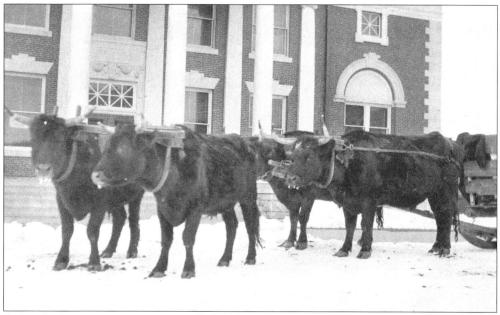

Before the big tractor, oxen were used to skid the logs into town.

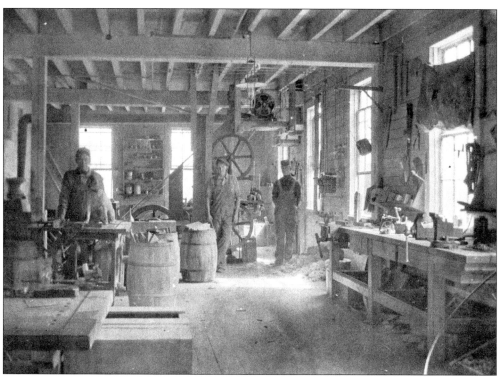

There was a sawmill just below the spillway at the Lake Mansfield Trout Club, owned by Willis Culver. Downstream from the mill, where the Michigan Brook joins Miller Brook, was a butter tub factory. This picture shows the inside of the butter tub factory. The writer of this postcard indicated that his address was "Lake Mansfield, Stowe, Vermont."

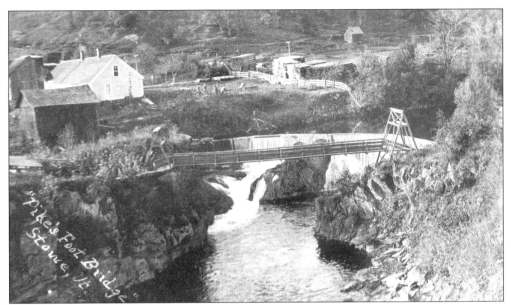

The P.D. Pike Mill in the Lower Village was also the home of a small violin factory run by a Swedish man. Located above a boiler room, it is likely that dust or lacquer fumes ignited the fire that destroyed that part of the mill in 1923. Gladys Knapp worked in the violin shop when she was in her teens. Her job was to sand the backs of the cases.

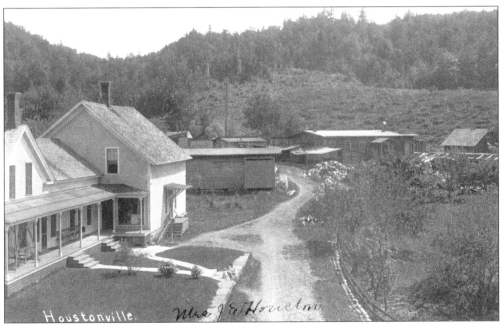

Located just north of the present Topnotch Resort, at what has been known as Bottomnotch, was the Houston's steam-powered mill that produced butter tubs. During its peak, *c.* 1910, about 100,000 butter tubs were made per year. Butter tubs used a good grade of wood well finished.

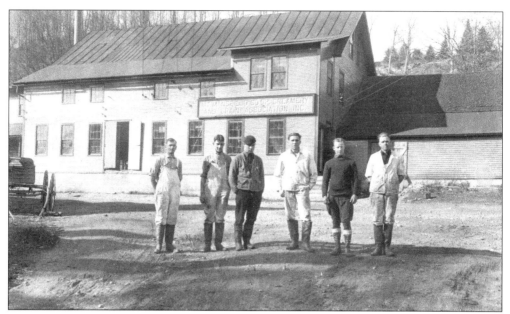

A June 1909 newspaper reported that Charles Eddy's creamery hade recently made more than a ton of butter in one day. The creamery later became a cooperative enterprise with member dairymen from Stowe and neighboring towns. Shown are workers at the creamery, including Albert Raymond and Neil Ellsworth.

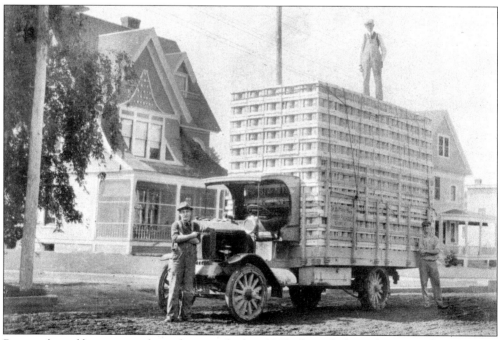

Butter tubs and boxes were a big industry in the late 1880s through the early 1900s, when the local dairies exported cheese. Pike's Mill, formerly G.M. Culver's business, was located at the Lower Village. During its peak at the turn of the century, 650,000 tubs were produced in Stowe. In this c. 1920 photograph, the sign on the truck says, "P.D. Pike & Son Butter Packages Stowe, Vt."

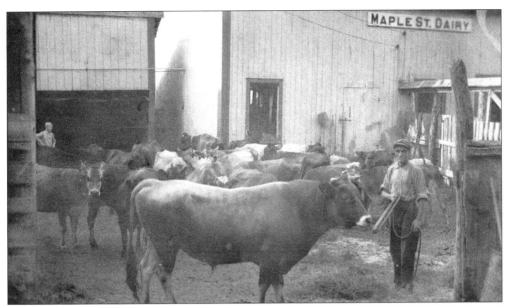

The Maple Street Dairy was first owned by Clyde and Dorothy Nelson. In 1939, Mrs. Nelson designed the famous skiing cow found on their milk bottles, which they delivered house-to-house. The man on the right is Clyde Nelson.

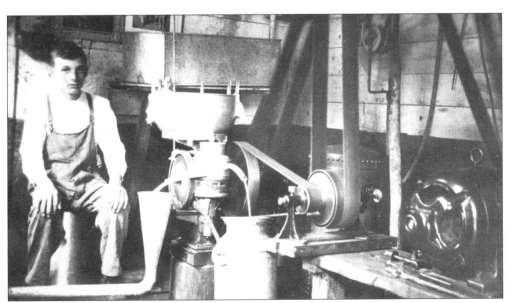

This young lad is watching the separator, where the milk went into the milk can and the cream into the funnel. The cream was used for butter, which was packaged and exported. The milk, which would not keep very long, went to the family and to the animals in their feed.

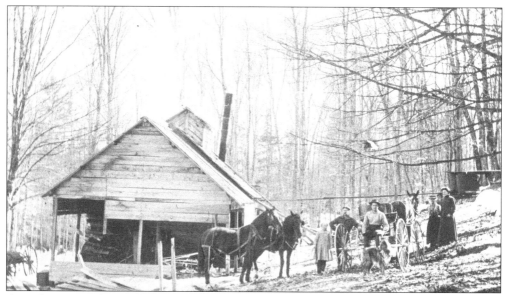

Over the course of time, there have been more than 200 sugarhouses in Stowe. In this view, the season is almost over, evident by the lack of wood stacked in the woodpile. Sugarhouses look very much the same all over Stowe and Vermont. Harry Slayton had a sugarhouse in Moscow near where the boys from Adam's Mill played baseball.

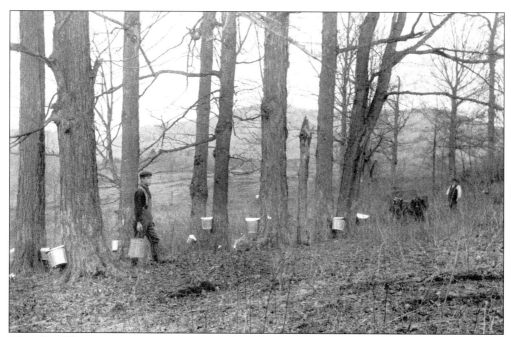

Chandler Watts was a prominent person in Stowe. For most of his life, he lived in Stowe Hollow on a 75-acre farm. He tapped about 600 trees, making a fancy grade of maple honey. IN this c. 1907 view, he has help from his friend Silas Stebbins (left).

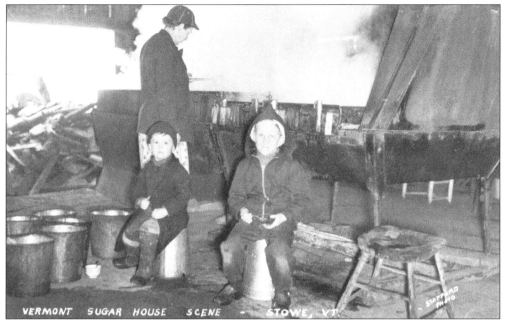

The Moodys' sugarhouse was just off Route 100 in the Lower Village near what is now a car wash. Grace Moody tends the boiler, and the children "helping" are Danny Moody (left) and Rod Stafford. The Moodys held a fall corn roast near their sugarhouse for many years.

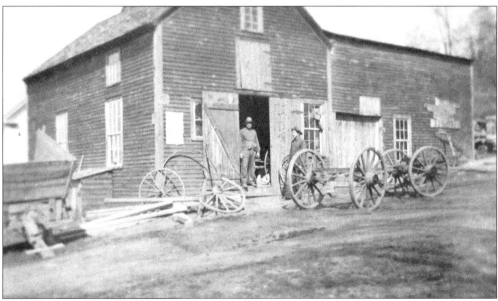

Lucius Morrill, the father of Clayton Morril, is standing in the doorway of his blacksmith shop in the very early 1900s at the bottom of Brush Hill where it meets Route 100. He was a wheelwright, making and fixing wheels, in addition to his blacksmithing. Around 1913, he went into the automotive repair business after he had converted a Cadillac touring car into a wrecker. Painted dark red, it had wooden wheels and a V-8 engine. When Lucius retired, Clayton took over the business. In the 1940s, Clayton moved it to Pond Street in the village. Brush Hill is named for the Brush family, relatives of Lucius Morrill.

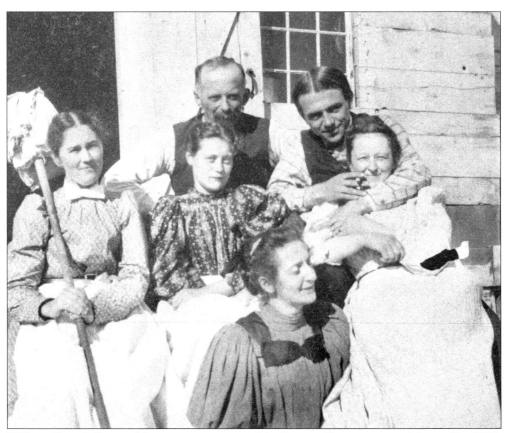

William Churchill, one of the many proprietors of the Summit House, poses with his staff in 1898.

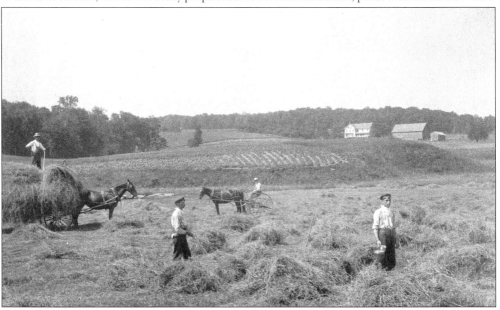

Chandler Watts, on the hay rake in the distance, oversees the haying of his field in Stowe Hollow c. 1907. The house in the distance is the Petersons' farm.

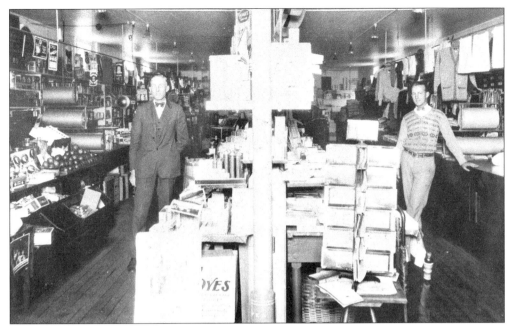

This store on South Main Street near the old Methodist church went through many ownerships. According to *The History of Stowe*, owners have included the following: P.D. Pike and Sons, 1894; Oakes & Benson, 1895–1898; Pike & Benson, 1898–1905; Eddy & Macutchan, 1905–1916; P.D. Pike & Sons, 1916–1923; and finally C.E. & F.O. Burt, 1923–1937. This photograph of Dalton Wells (left) and Harry Pike dates from *c.* 1932.

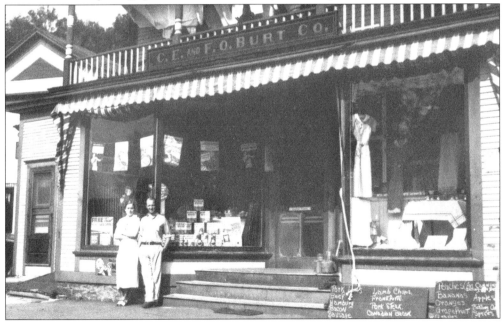

This photograph shows the same store as above, again with Dalton Wells. This week in 1936, there was a special on Rippled Wheat, as is evidenced by the big display in the left side window. A poster even claims a "free trial money-back offer." The chalkboards (to the right) tell us the variety of meats and fruits available.

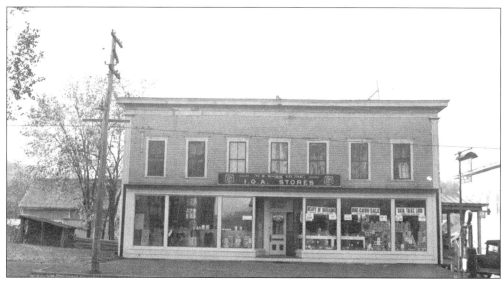

Howard Shaw was one of Stowe's entrepreneurs at the turn of the century. One of his many enterprises was Shaw's General Store on Main Street. The family has continued to operate the store to this day. In this *c.* 1930s photograph, the banners advertising "heaps of bargains" and a "big cash sale" also proclaim that "cash talks loud."

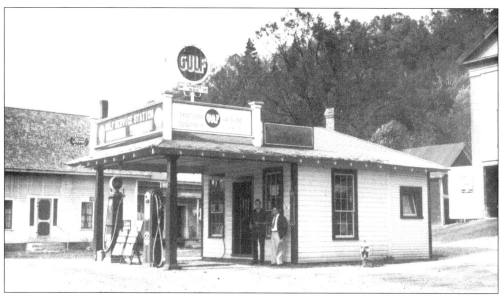

This gas station on South Main Street was next to the Burts' store. It was run by Lewis Pervier in the mid-1930s. Charles Wilkins was a good mechanic, working in the converted Methodist church seen behind the little gas station building.

Five

PLACES TO STAY

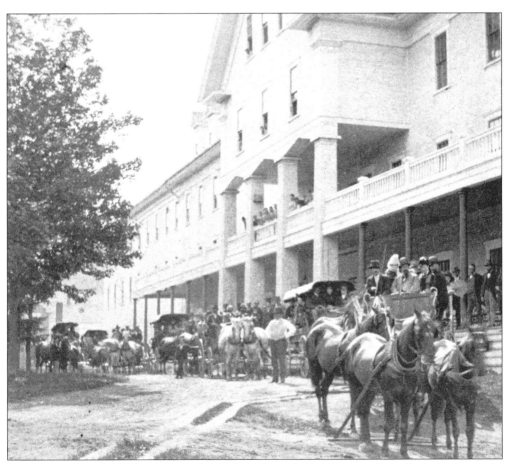

The Mount Mansfield Hotel, located on Main Street in Stowe, was often filled to capacity in the summer. Here, carriages are being readied for an outing to the mountain, c. 1870.

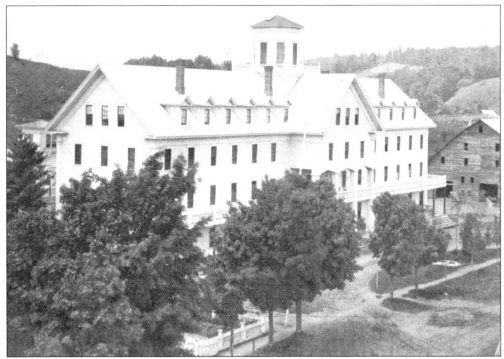

Built in 1864, the Mount Mansfield Hotel had ample room for 600 guests. It was an imposing building for such a small village. Many did not appreciate its impact on the town. It burned to the ground only 25 years later. At that time, rates were $3 a day, or $15 to $25 per week. Children under 10 and servants were half price. Silas Gurney was the general manager.

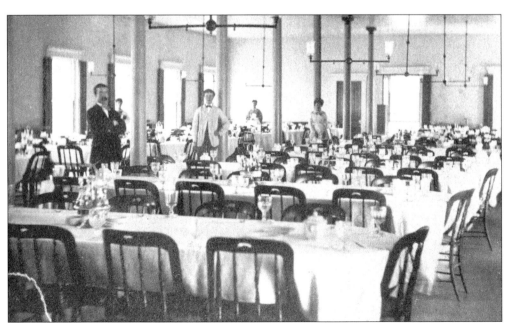

The dining room at the Mount Mansfield Hotel could seat 300 for dinner. The two men in this 1870 photograph are Charles and Merrillo Spaulding.

The huge barn and livery for the Mount Mansfield Hotel held 200 horses plus all the hay and feed. It was also used for carriages as well as for office space and rooms for the hired hands, c. 1870.

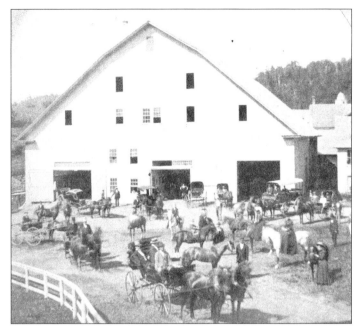

A favorite afternoon pastime at the Mount Mansfield Hotel was playing croquet. If it was not your turn or you did not feel like playing, you could watch from the bleachers.

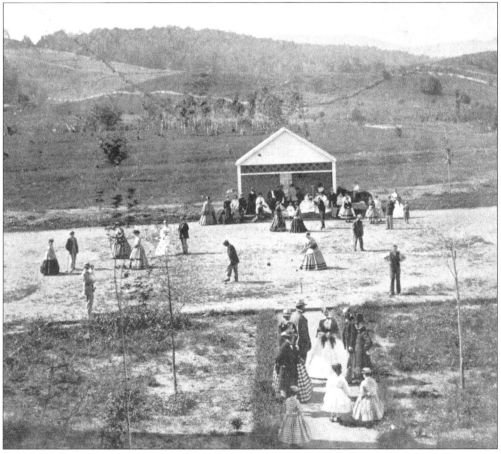

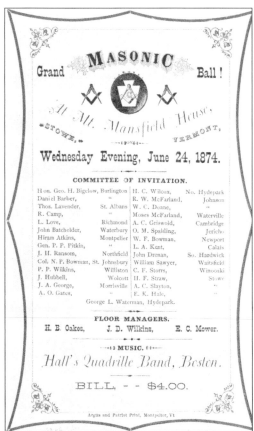

The Mount Mansfield Hotel provided the perfect venue for dances and balls of all sorts. People came from quite a distance to be "seen" at this particular event sponsored by the Masons for a Wednesday evening in June 1874.

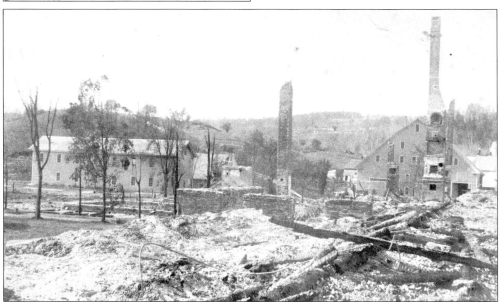

This photograph shows the remains of the great Mount Mansfield Hotel after it burned on October 4, 1889, while under the ownership of Silas Gurney. By some miracle, the livery barn, seen behind the chimney to the right, did not succumb to the blaze.

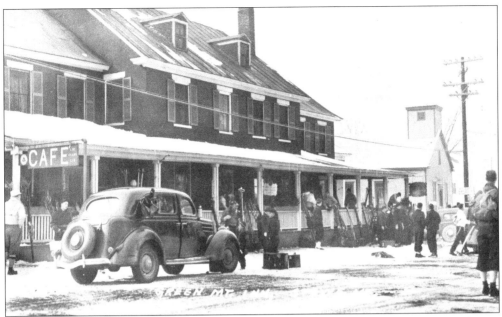

In this 1930s photograph, skiers wait on Main Street near the Green Mount Inn for the bus to take them to Waterbury to meet the trains that will take them home to yet another week of work.

Parker Perry, a proprietor of the Green Mountain Inn in the 1950s, always had a St. Bernard, which he drove around town in his Woody station wagons. Each dog was named Caesar plus whatever number he was, up to as many as 13. At one point, he had two dogs, so one had to be named Brutus.

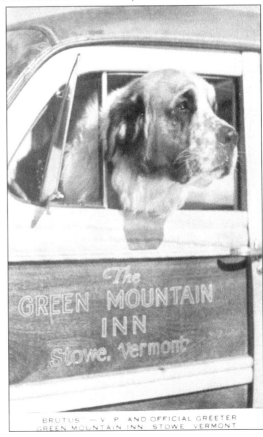

BRUTUS — V. P. AND OFFICIAL GREETER
GREEN MOUNTAIN INN STOWE VERMONT

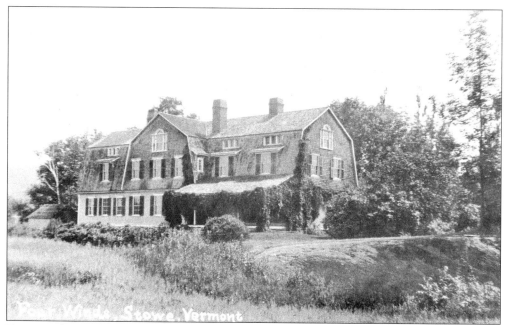

Four Winds was the home of the Holt-Taber family, who were well known in publishing. Mr. Holt's driveway approached from the right side of the house along the ridge line, a rather level approach. He convinced the town to abandon this road in favor of the steeper, more difficult road, known as Taber Hill Road. This would cut down on the amount of traffic going by his house. In later years, after World War II, under the ownership of Ted Barnett, and after renovations and refurbishment, Four Winds operated as a guesthouse.

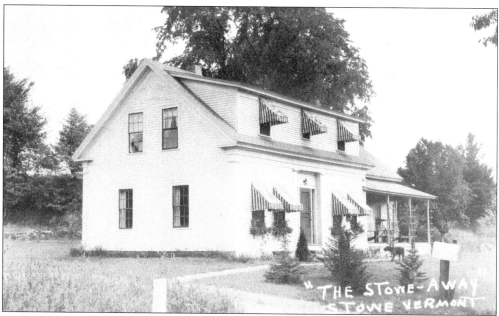

In the late 1930s, David Rutledge purchased this longtime farmhouse establishing it as the Stowe-Away. In 1942, he rented it to the Trapp family while their new Stowe property was being built for them. It remains a guesthouse and restaurant.

82

An avid skier, Erling Strom bought Mark Poor's farm in 1940 to operate it as a guesthouse. He installed a rope tow on the hill behind his house, run by a Model A Ford engine. Strom was instrumental in establishing a cross-country ski race in 1945 known as the Mansfield-Stowe Derby. Sepp Ruschp won the race that first year, but Erling Strom claimed the win in 1947 and 1949. This view of the Strom Lodge is from the early 1940s.

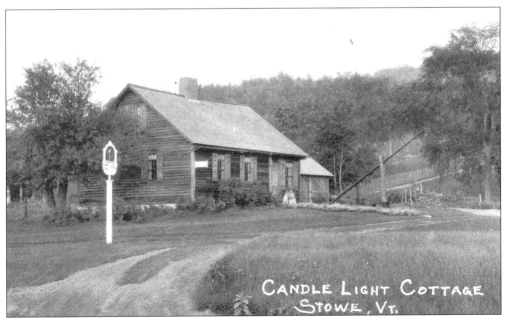

The Candlelight Cottage is one of the oldest houses in Stowe that is still standing, built c. 1800 or earlier. The 1943 *Vermont Yearbook* lists Charlotte Gilbert as the proprietor of a seasonal tearoom here.

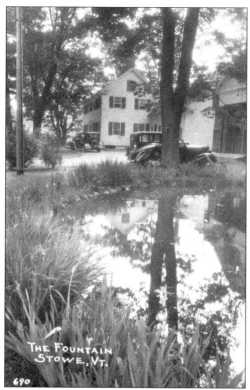

Located on Route 100 about a mile north of the village, this home began as the Noah Churchill farm in the mid-1800s. The pond was built at that time, but needed some work by the time the Fountain became a guesthouse in the summer of 1927 under the ownership of Mrs. W.C. Norcross. At that time, a new telephone was installed—the number was 7-16.

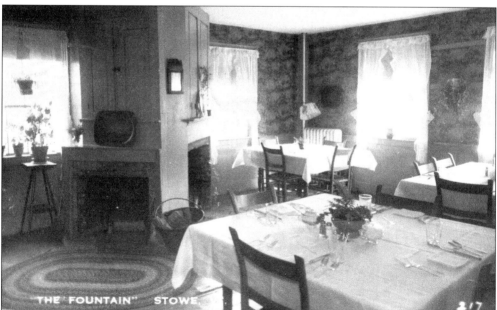

In the winter, the Fountain would accommodate between 16 and 20 guests, even before the lifts were in operation. Guests would get their breakfast and then head out with bagged lunches. They would return to a family-style dinner and dessert. In the summer, with some people spending a month at a time, the inn usually held around 15 guests. They were served three meals a day. The food editor of the *New York Times* even stayed there once!

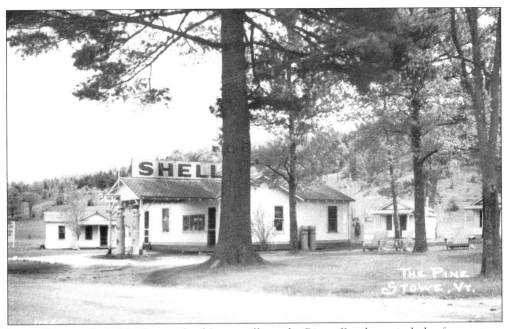

Located one and a half miles north of Stowe village, the Pine offered a main lodge for guests as well as a ten individual cabins, which were heated and had private bathrooms. In the 1940s, under the ownership of Quincy Magoon, guests could experience the 30-meter ski jump on the hill behind the lodge.

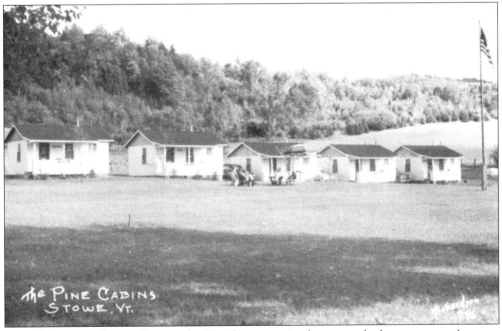

Five of the original ten cabins at the Pine have remained very much the same over the years through a succession of owners, including Quincy Magoon, Hal Shelton, Tony Ciaraldi, and currently Betty Bush. The gas pump and the little store are now gone.

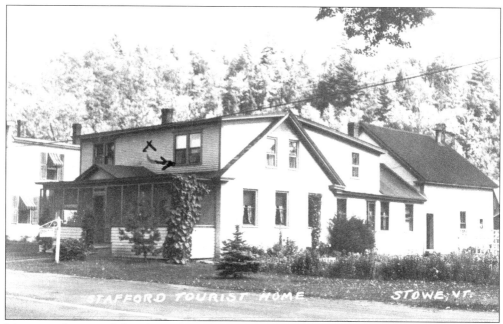

Many people opened their homes to guests. Breakfast was usually included in the price of the room. The Stafford house, shown *c.* 1950, was close to the village on Maple Street, next to the Parsonage.

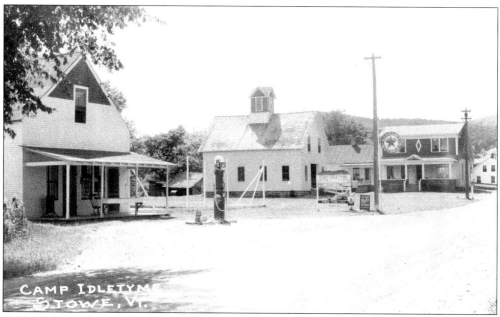

A Mr. Gilman Foster had a butter tub shop across the street from his home (the Foster House near the bottom of Harlow Hill), which he sold to Mr. Houston. He then moved to this site running a cider mill. Eventually, the property was purchased by Walter Sears, who established Camp Idletyme in the mid-1930s. Meant for the young people who were biking through Stowe needing lodging, Camp Idletyme had a store and offered tennis and dorm space for sleeping. In the winter, Sears took in guests in the main house only.

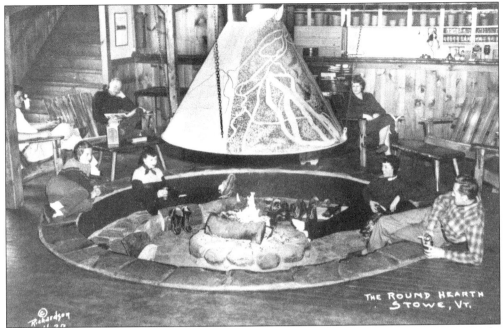

The Roundhearth was popular ski dorm on the Mountain Road. It was built in the 1940s by Charles Blauvelt and Graham Gilcrist. This fireplace was where the guests crowded around at night to share their skiing stories of the day. The man in the plaid shirt on the right is Gilcrist. The man in the back (by the stairs) in the dark sweater is Blauvelt. The woman seated on the right in the back is Peggy Gilcrist.

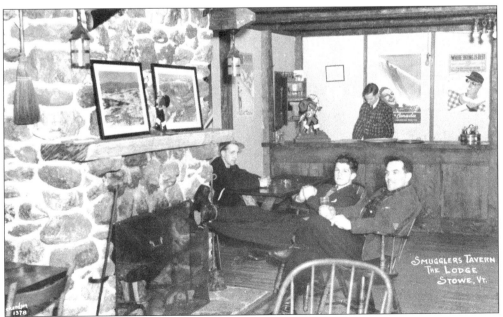

Stowe was known for its après-skiing as well as its skiing! Monroe Poor is the bartender at the Smugglers Tavern at the Lodge, c. 1940.

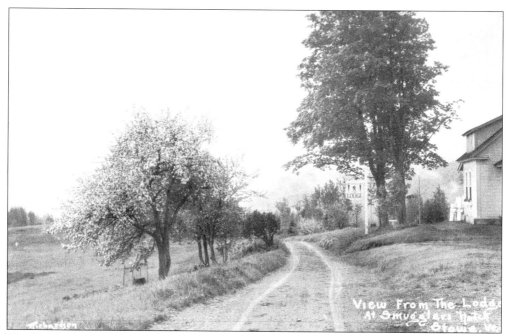

The lawn across from the Lodge was never mown, as is shown in this early photograph. When the Mountain Company bought it in December 1950, they had Neil Robinson mow it, even with snow on the ground. The blade just went under the snow, even though the snow held up the grass. They thought that with grass sticking up through the snow, it looked like it had not snowed very much. The field later became a golf course for the guests of the Lodge.

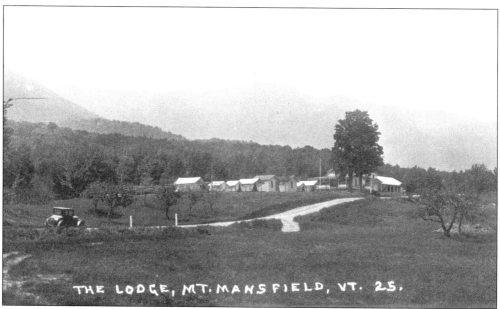

The Lodge, previously the farm of John Harris, opened its doors in 1923 as a summer camping area. Over the years, numerous additions and remodeling have made it the luxury resort it is today. This view dates to the mid-1920s.

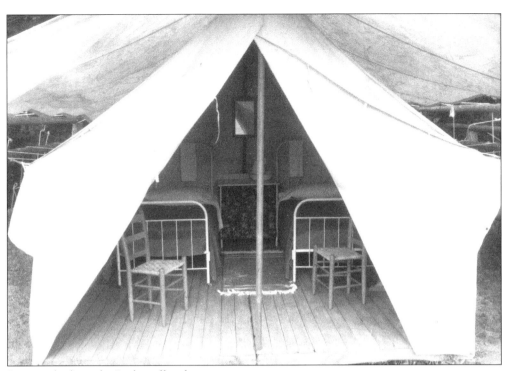

In its early days, the Lodge offered tents as its rustic accommodations. Each tent came on a wooden platform with two iron beds, a table and rug between them, two chairs, and towels, a water pitcher and bowl, and a mirror.

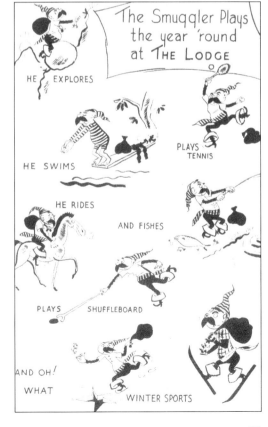

The Smuggler Plays the year 'round at THE LODGE

HE EXPLORES

HE SWIMS

PLAYS TENNIS

HE RIDES

AND FISHES

PLAYS SHUFFLEBOARD

AND OH! WHAT

WINTER SPORTS

Smugglers Notch was named for the smugglers who brought their wares from Canada through the narrow pass. The Lodge adopted the "Smuggler" as its mascot and used it for promoting the Lodge at Stowe as a four-season resort destination in the 1940s.

The story of the Trapp family is well known. In his quest to find the right place for his family to live, Baron Georg von Trapp ended up in Stowe, buying the property on Luce Hill in 1941. Here, he has taken some time to enjoy Mount Mansfield. He died in 1947.

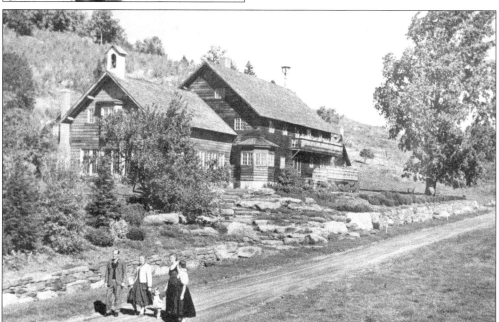

The Trapp Family Lodge was completed in 1943. The Stowe High School shop class, under the guidance of Anson Page, helped to build the lodge that year. Maria von Trapp gave the "kids" homemade bread with honey on it.

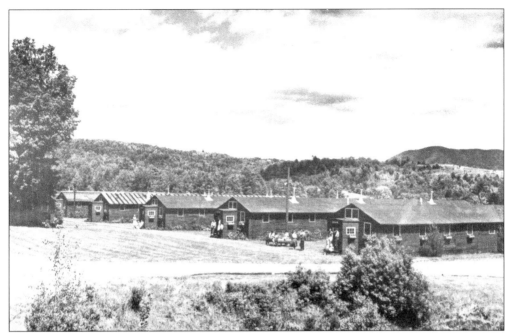

Civilian Conservation Corps barracks were built near the Trapp's property in the early 1930s as part of the Little River Dam Project (completed c. 1938). On May 24, 1944, the State of Vermont leased these unused buildings for ten years to the Trapps to use as dorms for their summer music camp.

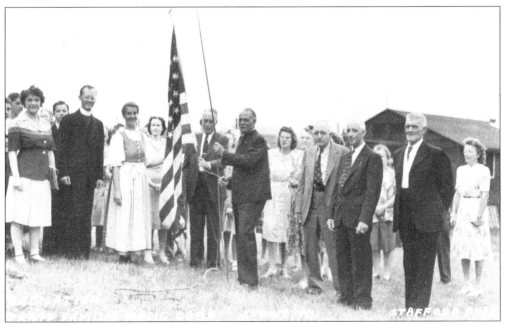

Present at the dedication of the Trapp Family Music Camp are Diana McMahon, Father Wasner, and Maria von Trapp. The man with the flag is most likely a member of the state or federal government. Next is Baron Georg von Trapp, Arne Ricketson, Fred McCarthy, and Neil Robinson. The last three were selectmen in Stowe.

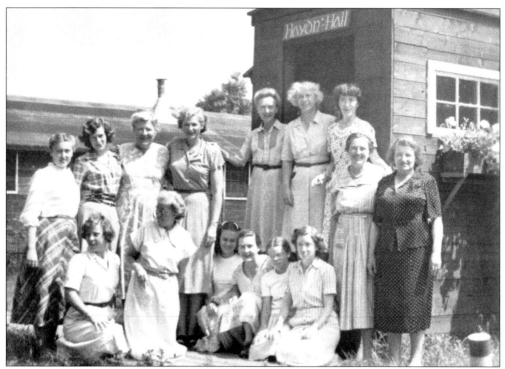

Each dorm building at the Trapp Music Camp was named for a famous composer. Here, students pose outside Haydn Hall. Others were Schubert, Beethoven, Mozart, Bach, and Stephen Foster Halls.

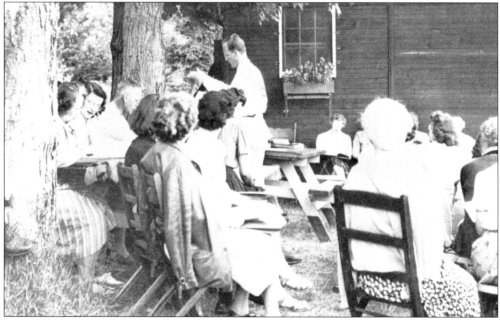

A typical day at the Trapp Music Camp began with morning chapel, then breakfast, followed by choral singing with Father Wasner, and then lunch. Father Wasner is pictured here leading the students.

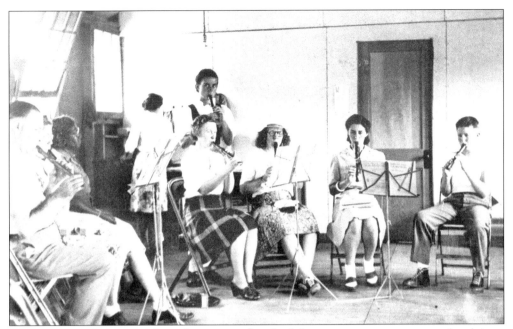

Afternoons at the Trapp Music Camp were free for hiking, swimming, or some other leisure activity. Recorder and violin lessons were available as well.

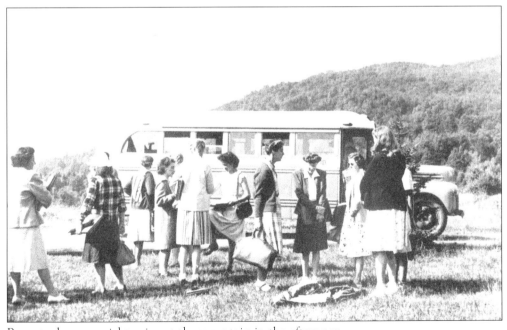

Buses took groups sightseeing at the mountain in the afternoon.

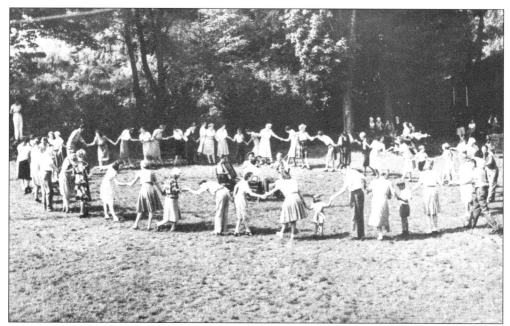

In the evenings at the Trapp Music Camp, Maria led the folk dancing lessons. Lights in the dorms had to be out by 10 p.m. The camp closed its doors the summer of 1956.

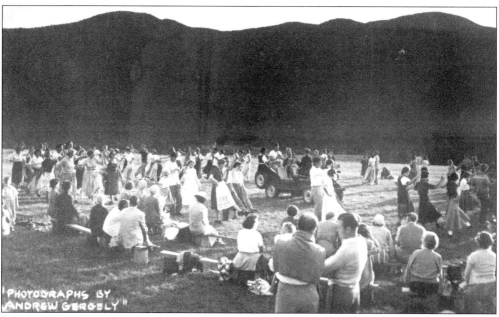

"PHOTOGRAPHS BY
ANDREW GERGELY"

For the 25th anniversary of the Trapp family's arrival in Stowe, a service was conducted by Rabbi Max Wahl, Bishop Joyce, a minister from the United Church of Christ, Reverend Brayton, Father Campbell, and Monsignor Wasner. A sap bucket was passed for the collection. The Festival of Music in 1956 was the last time the Trapp family sang together.

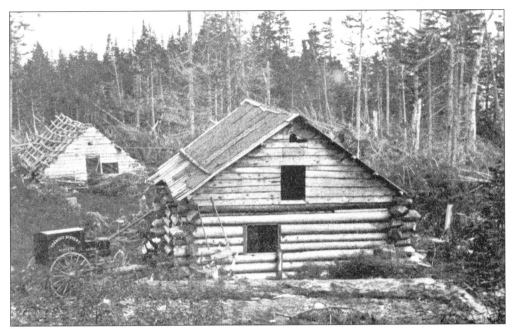

Byron Russell and his crew of men finished building the upper part of the road to the Summit House in 1870. Russel, his family, and his crew lived in these cabins for the two years it took to do the job. The wagon in the picture belongs to the photographer. On its side it says, "Vermont Scenery Stowe, Vt. N.L. Merrill."

Shown is the Summit House on top of Mount Mansfield in 1870. On the steps are Mr. and Mrs. Abial Spaulding, Sarah Spaulding (waitress), and Mary George (chambermaid). John Dubray was the house man at that time and Louis Demous, in the hat, was the cook.

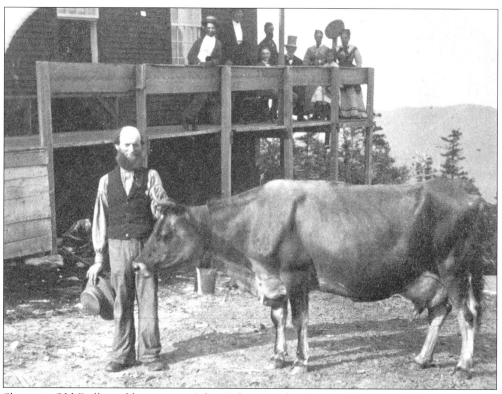

Shown is Old Dolly and her master, John Dubray, at the Summit House in 1870.

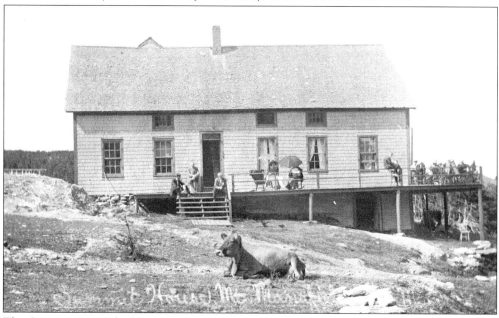

The Summit House, built in 1858, was sited just steps from the base of the Nose on Mount Mansfield. By 1860, an addition to the structure had been added. For a short while, it was also known as the Tip Top House, the Mountain House, and even the Mount Mansfield House. The resident cow provided fresh dairy products for the guests.

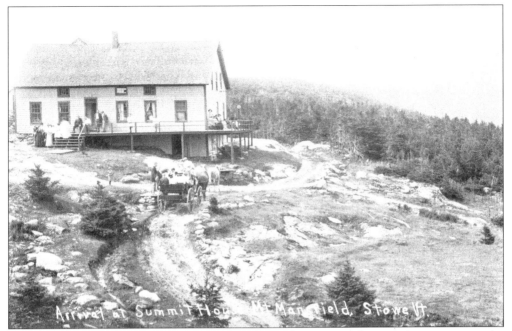

The Mount Mansfield Hotel, located in the village of Stowe, ran day trips for its guests to the top of the mountain. Often these guests stayed overnight on the mountain. By 1866, the Summit House could accommodate 50 guests.

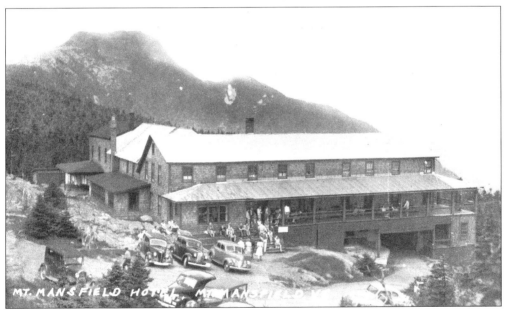

The Summit House stood for 107 years on the top of the mountain. A popular resort in horse and buggy days, in 1923 it was enlarged and hot water and electricity were installed. It closed in 1957 and cleaned of its valuables. It was razed in 1969. This view shows the hotel's popularity in the mid-1940s.

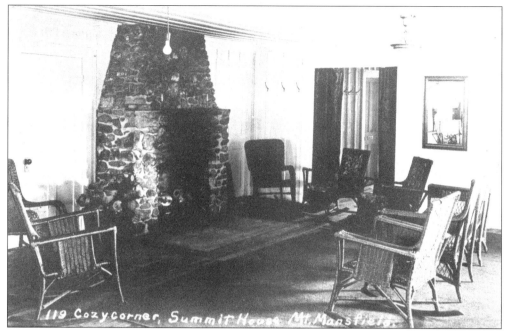

People from all walks of life gathered around the fireplace to share stories and to get warm. This photograph was taken *c.* 1920s.

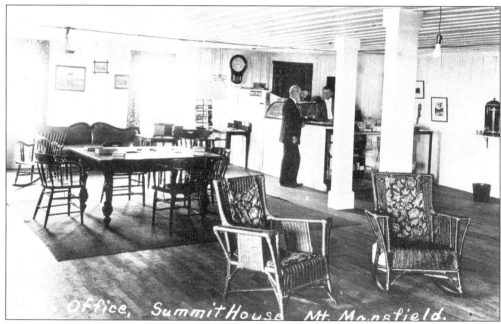

The clock near the office desk at the Summit House was unique, as it had a marble face and came from the ill-fated Mount Mansfield Hotel in the village. From the display case at the desk, one could get postcards and souvenirs, trinkets and candy. The hotel had its own post office, so mail sent from there was canceled with a Mount Mansfield stamp, *c.* 1940.

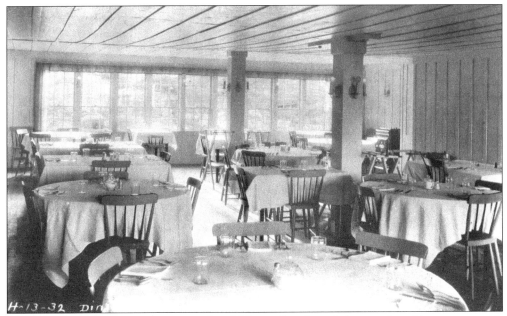

Dinner at the Summit House was served at 6:30 p.m. Simple and elegant, the tables were set with nice linens. You had to "BYOB" for dinner, but there was no drinking in the lobby.

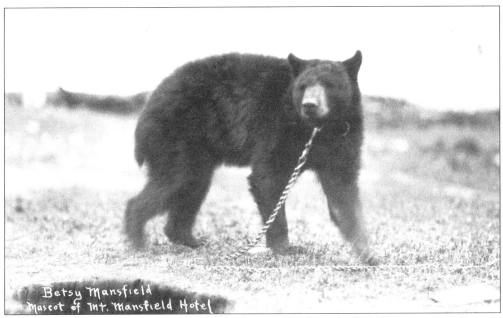

Betsy Mansfield
Mascot of Mt. Mansfield Hotel

Around 1930, the mother to this cub was shot. Craig Burt kept the little bear in a specially built pen at the tollgate at the base of the Toll Road. She was kept in a box stall in Burt's barn on Maple Street in the winter. In the spring, the bear would go back to the mountain. This went on for several years until the bear got too old and mean to be safe.

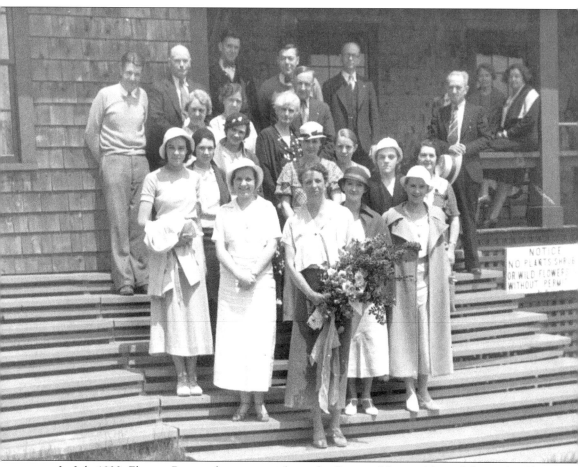

In July 1933, Eleanor Roosevelt spent a night at the Summit House. After a hike to the Chin, she met and posed for pictures on the hotel steps with Carolyn Pike, who presented the flowers; Helen, Lillian, and Dorothy Burt; Dorothy Bodman; Thelma Oakes; and Kathryn and Carolyn Pike. Roosevelt was the first First Lady to visit Mount Mansfield.

Six

THE MOUNTAIN

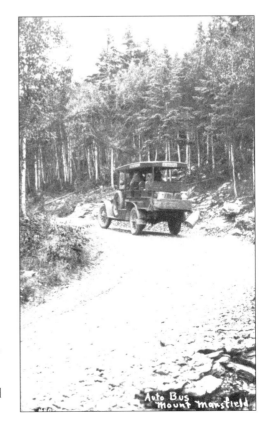

Reconstruction of the Toll Road was completed in 1922. Earlier, it had been too steep and rutty a road for carriages. The steep climbs and sharp corners were reduced, and the road's surface was evened with layers of crushed gravel, making it suitable for cars and auto-buses such as this one.

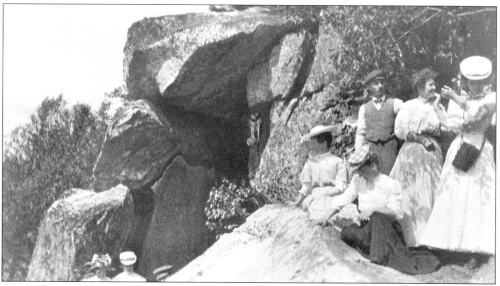

This *c.* 1900 picture shows a ladies' outing at the top of the mountain. They are at the Eye of the Needle, a rock formation just under the Nose.

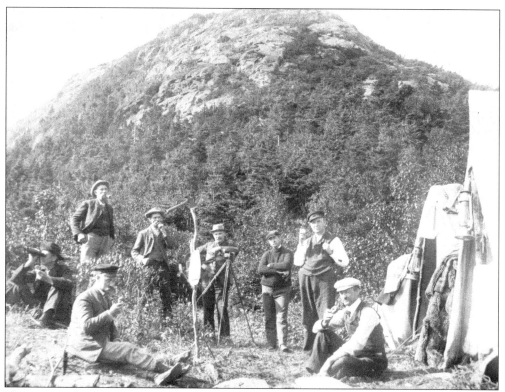

This picture shows a group of well-dressed campers on top of the mountain eating doughnuts.

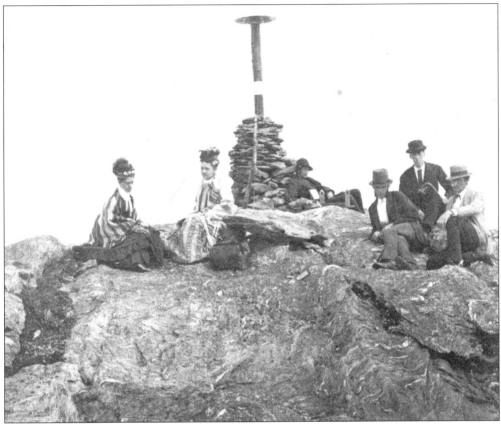

This view shows the cairn made in memory of President Grant at the time of his death in 1885. This pile of rocks was added to by hikers over the years.

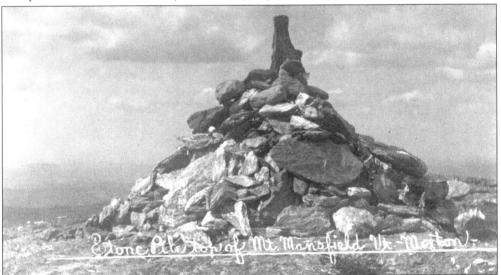

This c. 1940 picture shows the cairn near the Summit House at the top of Mount Mansfield. The Green Mountain Club, in one of its early guidebooks, mentions the pile of rocks as Frenchman's Pile, marking the location of a man who was killed by lightning.

The Mount Mansfield section of the Long Trail was cleared in 1911; Craig Burt Sr. was one of the men in charge. In 1920, Elihu Taft financed the building of Taft Lodge, the oldest existing Long Trail shelter. Accommodating 32, it is also the largest of the cabins. This early photograph shows the cabin still in need of a door and windows.

The top of mountain has seen many school field trips and scouting adventures over the years.

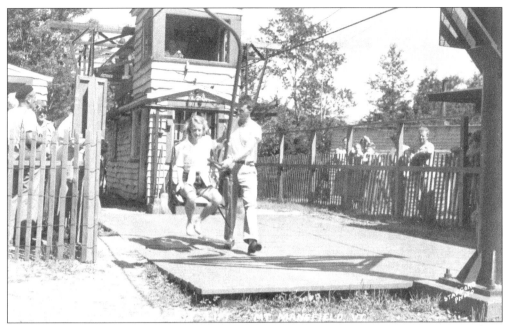

Perry Nay assists a young lady onto the Mount Mansfield single chairlift in the mid-to-late 1940s.

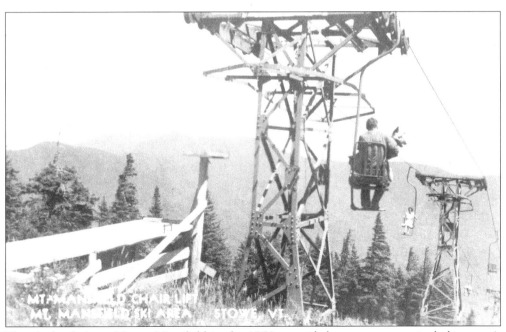

The single chair on Mount Mansfield in the 1950s provided summer guests, including man's best friend, with easy access to the top of the mountain.

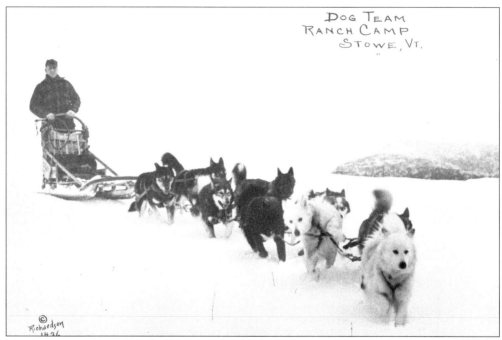

The guests staying at Ranch Camp would ski from Foster's (near the bridge at the base of Harlow Hill) into camp. Their luggage was taken in with a dog team led by Dick Hinman, the manager of the Ranch Camp in the mid-to-late 1940s.

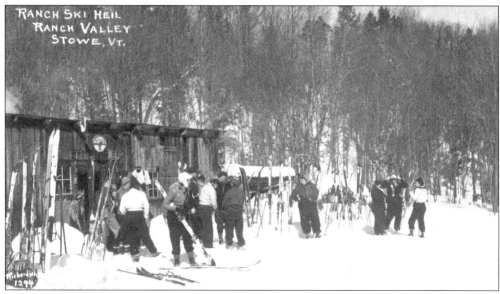

The Ranch Camp opened in 1933 as a ski shelter accommodating 50 people. There were bunkhouses, a main building (mostly used as a kitchen), a dining room and general gathering place, and a storage shed. An outbuilding housed a generator that provided sporadic electricity. Accommodations were rustic and inexpensive, particularly if you were willing to provide your own blanket and haul wood for the fire. Each succession of managers brought a different character to the camp's personality until it closed in 1950. This photograph dates from c. 1939.

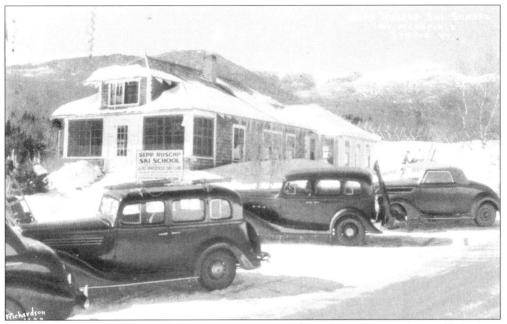

Sepp Ruschp came to Stowe the winter of 1936–1937. The following winter, he established the official Sepp Ruschp Ski School at the Toll House.

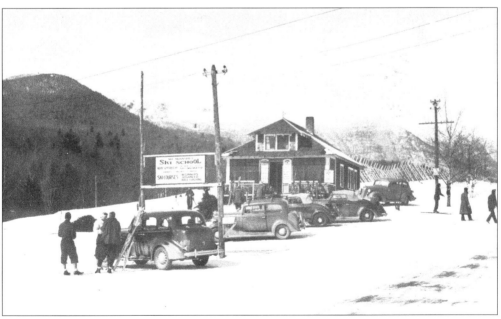

This building is the original Toll House and was the access to the bottom of the Toll Road in the 1930s. The first rope tow on Mount Mansfield was at the Toll House, which opened in 1937. It was 1,000 feet long, powered by a 1927 Cadillac engine, and cost 50¢ a day to ride.

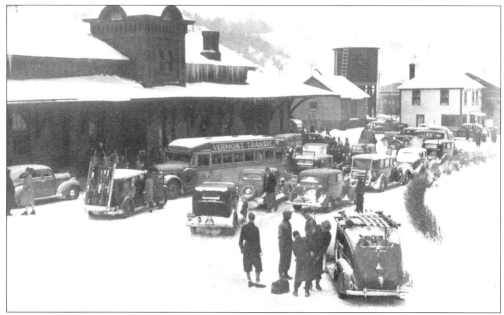

With the electric trolley no longer running, the Mountain Company gave Clovis Couture the money to buy a car to start a taxi service from the Waterbury train station to Stowe under the stipulation that he also pick up the Mountain Company guests and deliver them to their hotels.

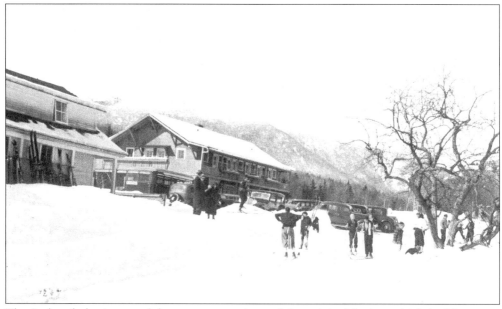

The Lodge chalet is one of the many expansions of the original Lodge, which had begun in 1923. Located just up the road from the Toll House, it provided easy access to the Toll Road, the Bruce Trail, and Ranch Camp.

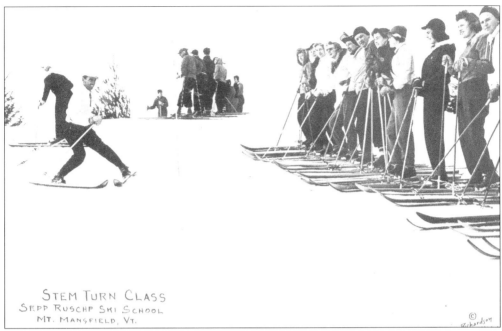

STEM TURN CLASS
SEPP RUSCHP SKI SCHOOL
MT. MANSFIELD, VT.

As a member of Sepp Ruschp's ski instructing staff, Clement Curtis demonstrates the nuances of making a Stem Christie Turn to a class at the Toll House slopes. He taught for two years before going into military service. Upon his return to Stowe and the mountain, he assumed many different positions of leadership with the Mountain Company. The most famous person he ever instructed was Lowell Thomas, the well-known radio broadcaster who came to Stowe often.

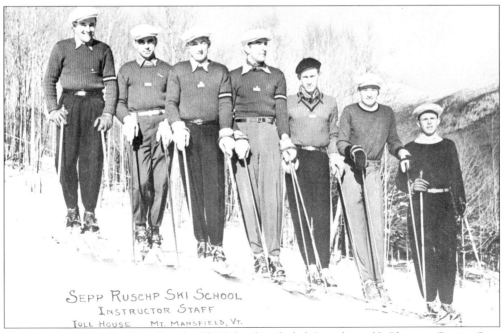

SEPP RUSCHP SKI SCHOOL
INSTRUCTOR STAFF
TOLL HOUSE MT. MANSFIELD, VT.

In the early 1940s, the Sepp Ruschp Ski School included Sepp himself, Clement Curtis, Otto Holhaus, Kerr Sparks, Lionel Hayes, Howard Moody, and Norman Richardson.

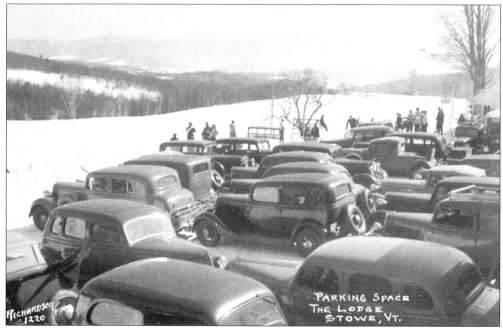

Skiing was much more important than worrying about traffic and parking management in the 1930s.

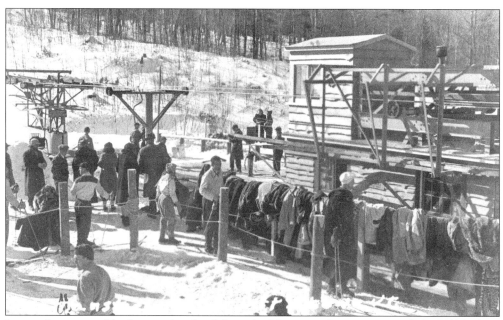

It was often very cold riding up the chairlift, so the Mountain Company provided wool blankets for the skiers to wear up the lift. The attendant at the top would put the blankets back onto the chair for the ride down to be made available again for the next skier. Some people would wear their own heavy fur or wool coats up the lift, taking them off for the return trip down, and would find them again for the next ride up. There was little fear that someone else would take the "wrong" coat.

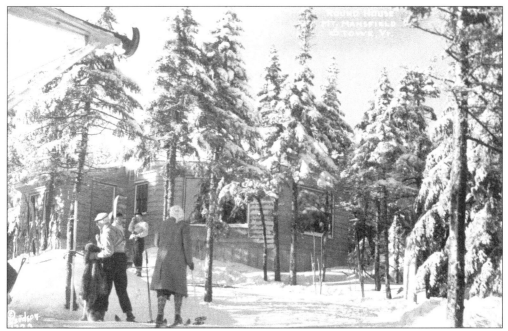

When the single chairlift on Mount Mansfield opened in 1940, skiers were also provided with a warming shelter at the top called the Round House, also known as the Octagon. This building has been expanded over the years to include a large deck and telescopes for viewing the valley below.

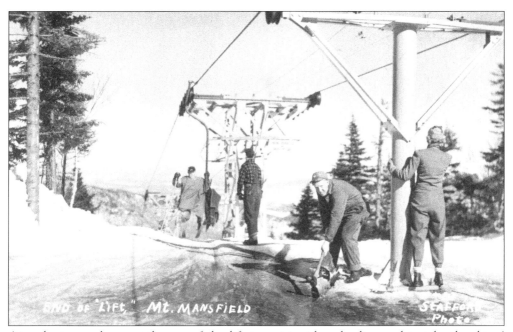

Attendants are always at the top of the lift to assist with unloading and to take the skiers' blankets. Here, Lyle Raymond keeps the melting ice under control in the mid-1940s.

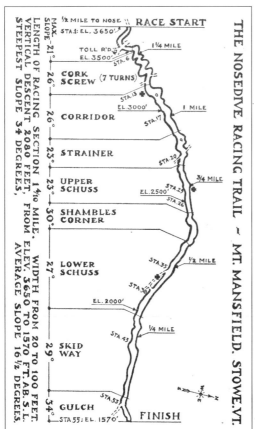

THE NOSEDIVE RACING TRAIL ~ MT. MANSFIELD. STOWE.VT.

MAX. SLOPE-21°. LENGTH OF RACING SECTION 1⁴⁄₁₀ MILE. WIDTH FROM 20 TO 100 FEET. VERTICAL DESCENT 2080 FEET. FROM ELEV. 3650 TO 1570 FT.AB.S.L. STEEPEST SLOPE 34 DEGREES, AVERAGE SLOPE 16½ DEGREES.

½ MILE TO NOSE — RACE START — STA.1: EL.3650' — 1¼ MILE — TOLL R'D EL.3500' — STA.6 — CORK SCREW (7 TURNS) — STA.13 — EL.3000' — 1 MILE — CORRIDOR — STA.17 — STRAINER — STA.20 — UPPER SCHUSS — EL.2500' — STA.25 — STA.26 — ¾ MILE — SHAMBLES CORNER — LOWER SCHUSS — STA.35 — ½ MILE — STA.39 — EL.2000' — STA.43 — ¼ MILE — SKID WAY — STA.53 — GULCH — STA.55; EL.1570' — FINISH

The famous Nose Dive trail was the first developed trail on the mountain. It was designed and cut by Charlie Lord and the CCC. It had the reputation for being the fastest trail in the East for many years. The section of the trail known as Shambles Corner was a dangerous place for racers, as there was a 2-foot diameter tree in the trail. It was finally removed after having collected many skiers!

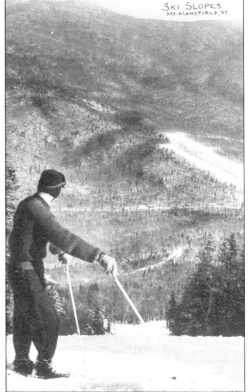

SKI SLOPES MT. MANSFIELD, VT.

In 1954, the sender of this postcard writes, "Daddy says he is going to take me up to the top of this mountain tomorrow morning but I'm not sure how I'm going to get down again."

In 1952, Stowe hosted the National Championship Downhill Ski Races on the Nose Dive trail. Already famous as one of the fastest trails, that year brought the extension of the trail to the top of the Nose, adding another 500 vertical feet. As this postcard shows, the trail is now 1.75 miles long with a vertical drop of 2,500 feet.

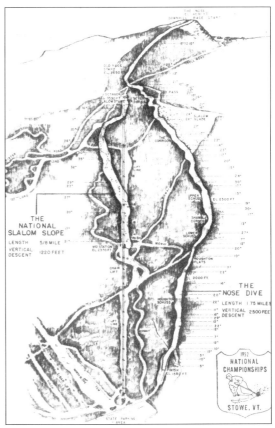

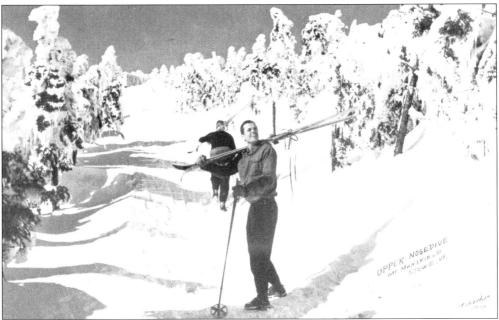

This is the only way to get to the Upper Nose Dive trail. Left ungroomed, it was not for the faint of heart in 1954 (or any other year).

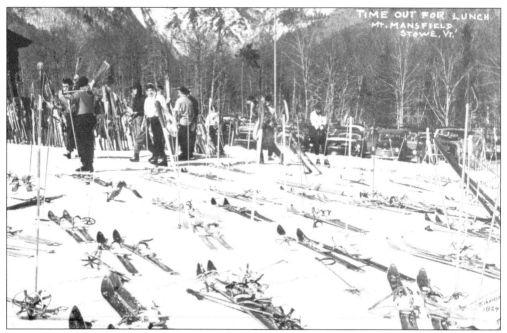

When the ski racks were full, it was a common practice to leave your skis wherever you could find a spot, as in this *c.* 1955 image.

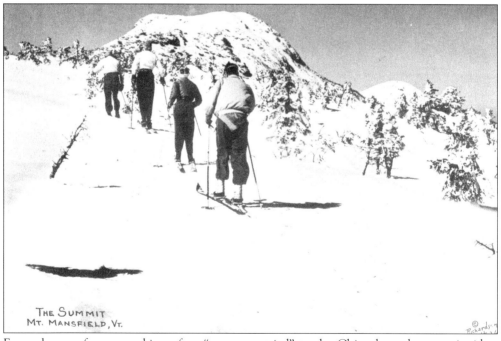

For a change of scenery, skiers often "cross-countried" to the Chin along the summit ridge. From the Nose to the Chin is about a mile. This photograph dates from *c.* 1944.

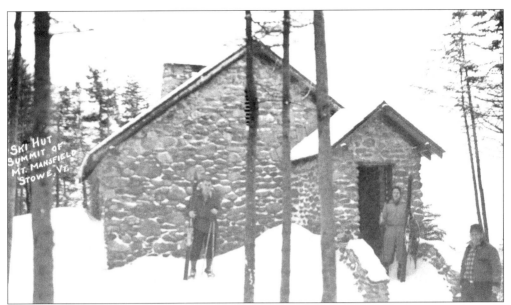

The Stone Hut, near the top of the lift on Mount Mansfield, was built by the CCC in the early 1930s about the same time the Nose Dive trail was being cut. At one point, a caretaker lived there and sold coffee and sandwiches to those who hiked up the Toll Road to ski. Local Boy Scout troops often stayed at the Stone Hut on outings.

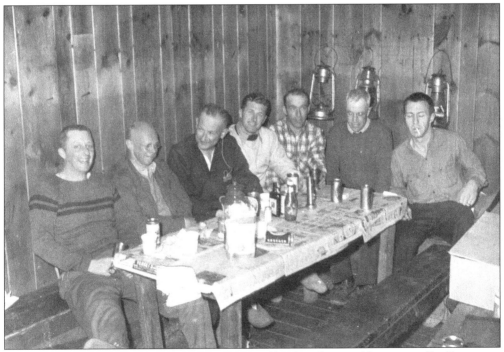

In the early-to-mid-1940s, the Stone Hut was used by the Ski Patrol between calls. Shown are Warren Warner, Abe Colman, Huntley Palmer, Chet Dudge, Linde Adams, Charlie Lord, and David Burt. George Wesson, the chief patrolman at the time, took the picture.

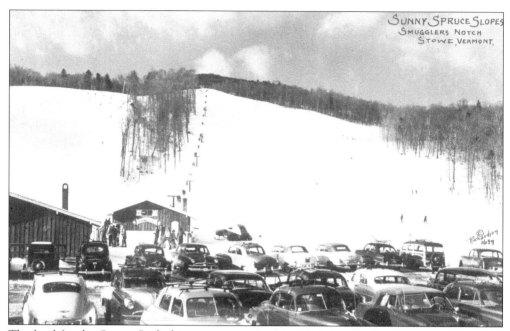

The land for the Spruce Peak ski area was acquired in 1946, but the slopes were not ready for skiing until the 1949–1950 ski season. At that time, this area was called the Sunny Spruce Slopes, and offered two rope tows for the skiers. The following year, the T-bar shown here was installed.

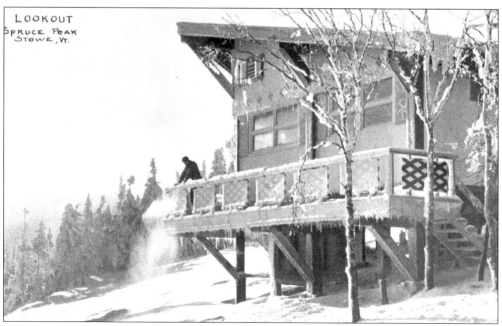

Facing the valley below and the mountain to the west, the Lookout was often wind-swept and icy. Inside, however, one was able to warm up with hot chocolate before the ski down.

Seven

THE NOTCH

Between 1915 and the mid-1920s, in an
agreement with the Green Mount Club,
UVM students managed the operations at
Barnes Camp. During World War I,
however, the camp was closed to visitors and
was used by road crews that were improving
the road through Smugglers Notch.

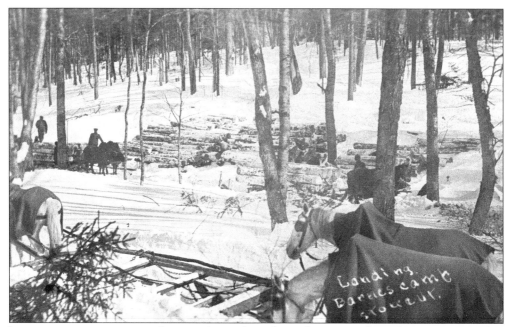

Logging was an important industry in Stowe from the mid-1800s to about the 1930s. From this, sawmills and woodworking trades flourished. Here is one such logging operation, based at Barnes Camp, so named for Willis Barnes, a logging boss at the time. He built this camp for his wintertime crews *c.* 1910.

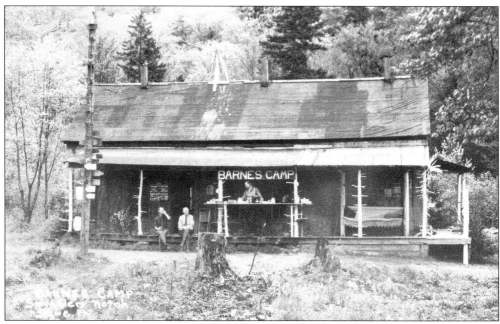

Before 1920, the Green Mount Club's development of the Long Trail brought forth an increase in the number of hikers and passers-by. Although Willis Barnes intended his camp to be a winter home for his logging crew, he soon found himself providing summertime accommodations to this new trade. When he moved his logging operation to another section of forest, the camp closed.

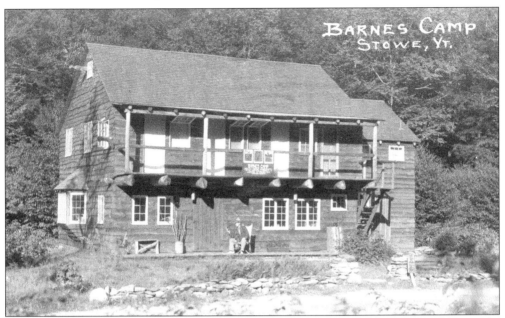

The C.E. & F.O. Burt Company acquired the Barnes Camp property and in 1927 tore down the old camp, rebuilding a rustic lodge with a large stone fireplace. There were enough private rooms for 16 guests and dormitory space for 30 in the 1930s.

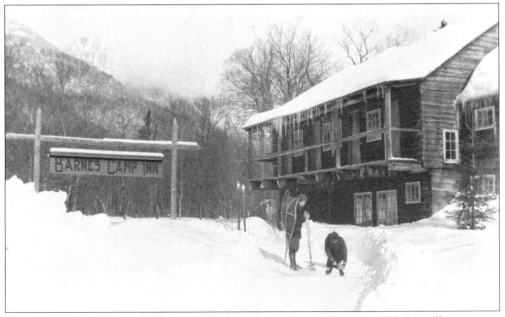

Four men, including Chelsea Lyons, took the helm at Barnes Camp in 1932. Initially a summer camping shelter, it was also the time of the birth of skiing on Mount Mansfield. Lyons found himself running his lodge year-round.

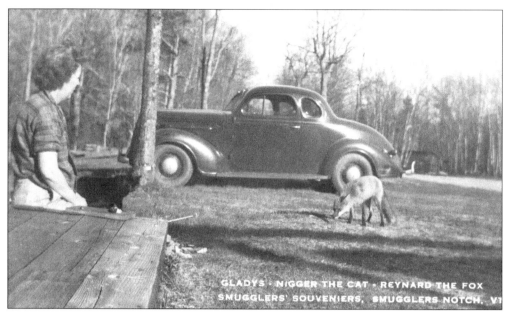

GLADYS · NIGGER THE CAT · REYNARD THE FOX
SMUGGLERS' SOUVENIERS, SMUGGLERS NOTCH. VT

Gladys Bryant leased the new Barnes Camp for five years. From about 1927 to 1932, she lived there with her pets, shown in this photograph.

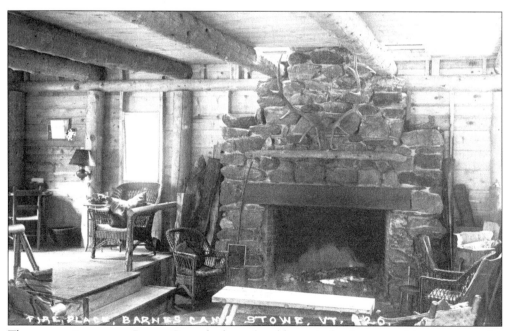

FIRE PLACE, BARNES CAMP, STOWE, VT, 20.

The cozy main room at Barnes Camp had comfortable rustic furniture, a writing corner, and a fireplace large enough to hold 4-foot logs.

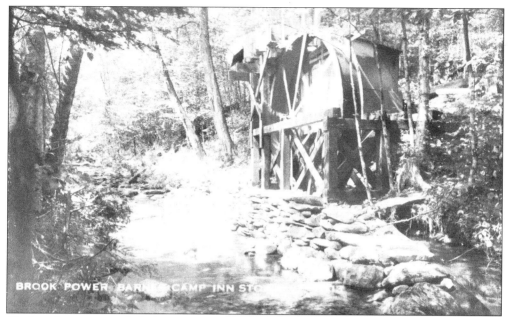

Chelsea Lyons expanded the camp and added some cabins across the road. Having an engineering background, he built an electric system by harnessing the water to power his homemade generator. He called his place Lyons Lodge and marketed it as being "Nearest All Ski Lifts." The name never stuck. It is still known today as Barnes Camp.

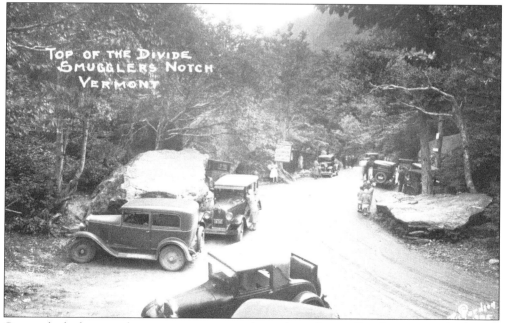

Cars parked wherever there was room among the rocks and trees. People came to climb or to try to find the many rock profiles and features. In part, these include the Hunter and His Dog, Elephant's Head, the Singing Bird, the Bear, Burton's Rock, the Katzenjammer Woman, the Giant's Face, the Watch Dog, or King Rock.

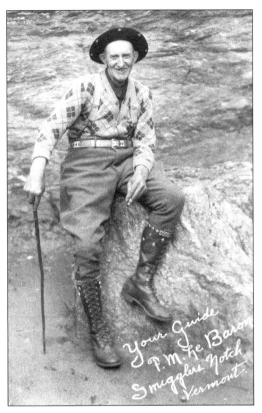

Your Guide F. M. Le Baron Smugglers Notch Vermont.

In the late 1920s and early 1930s, F.M. LeBaron was the self-appointed "guide extrordinaire" of Smugglers Notch. He greeted the visitors with his knowledge of the notch and all its rock features. He willingly posed for photographs. Wintering in Cambridge (the other side of the notch), he crafted walking sticks and other wooden trinkets to sell as souvenirs to visitors. When the State of Vermont regulated the use of the area, they allowed LeBaron to continue his service, but no one since has had that privilege.

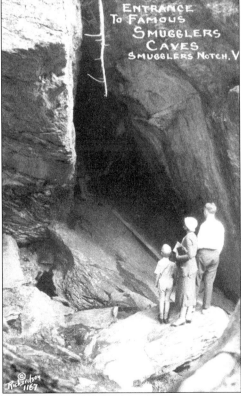

ENTRANCE To FAMOUS SMUGGLERS CAVES SMUGGLERS NOTCH, V

Smuggler's Cave is one of many caves created by the jumbled piling up of huge granite boulders over the years as they have fallen from the high cliffs. There are many stories about the depths and distances one can squeeze through there. At the Natural Refrigerator cave, the air maintains a cool 49 degrees. Some tourists just look, but most enjoy the exploring.

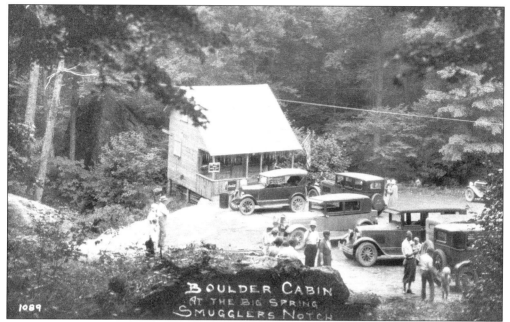

The concession Boulder Cabin at the Big Spring was originally built in 1930 or 1931 (and later expanded), near the site of the Notch House. It was managed by a daughter of L.S. Morse, a Cambridge man who owned the Big Spring and much surrounding acreage on the Sterling Range. It was a very popular spot for tourists until 1940, when the State of Vermont added this land to the Mount Mansfield State Forest, ending any development or enterprise.

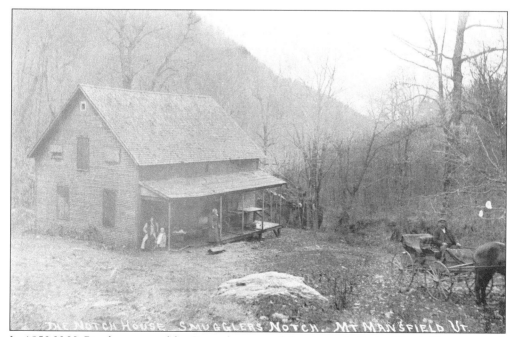

In 1852 H.H. Bingham, a wealthy Stowe lawyer and developer, built the Notch House, a small lodging facility near the Big Spring. It was abandoned after only seven years of operation.

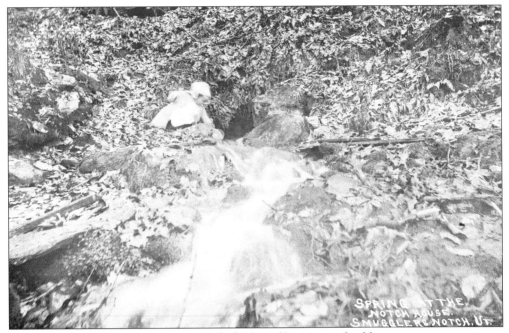

A very young guest at the Notch House helps herself to a cup of cold water.

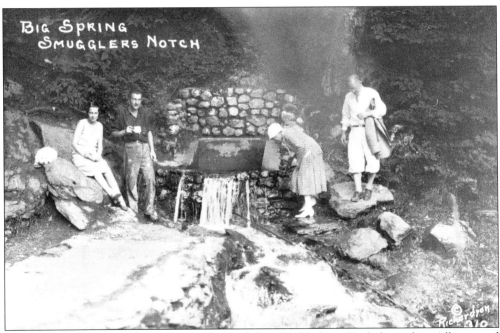

The little dog resting on the rock to the far left is Teddy Jim. He belonged to Alberta and Llewellyn Shafer, the manager and cook at Boulder Cabin. To the right of the spring are thought to be Harry and Alice Richardson. The sign at the spring promised the water to be 99 percent pure and always a cold 39 degrees.

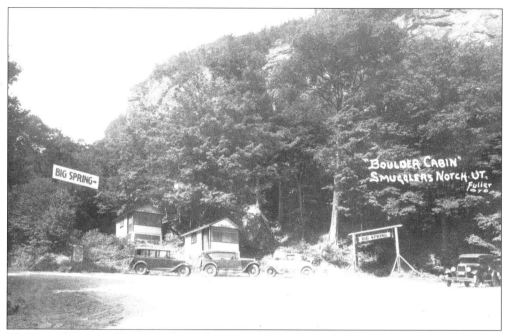

The two cabins, Boulder Hi and Boulder Lo, at the Big Spring in Smugglers Notch were rented out to tourists. At the main building, Boulder Cabin, meals and snacks were available. The menu board on the left offers, "Goodyear's Maple Syrup, barbecue steak, sandwiches, roast pork and roast beef, rooms . . . cakes, and hot dogs."

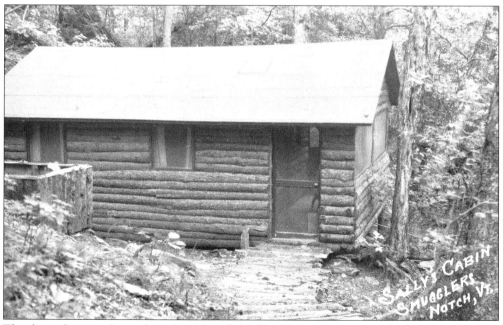

This log cabin was located to the right of the Big Spring sign, across the brook and over a wooden log bridge. Pearl Morse Shafer, her son Llewellyn, his wife Alberta, their baby Sally, and the family dog Teddy Jim lived in "Sally's Cabin" while they ran the business.

125

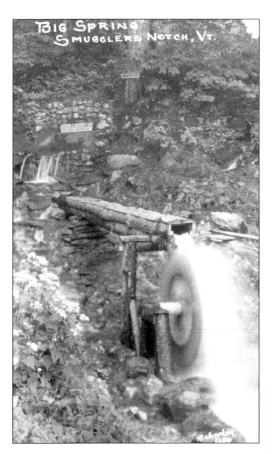

The water from the Big Spring ran down the trough into a small dammed pool that held trout imported from New York State. People paid for the use of a pole, a hook, and worms to catch the trout. They could take their catch into Boulder Cabin to be dressed and cooked for dinner. This was a fun attraction for the tourists.

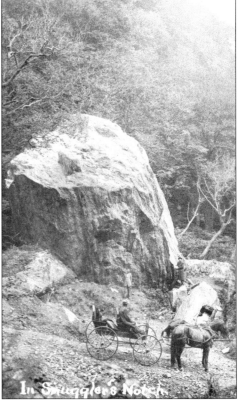

This is a very early photograph of visitors to King Rock. It fell from high on the cliffs in the winter of 1910–1911. Some men in a nearby lumber camp heard the noise and saw the dusty aftermath of the fall. It plowed a great path down the mountainside and dug a large divot in the earth before coming to a rest. It is estimated to weigh 5,000 tons.

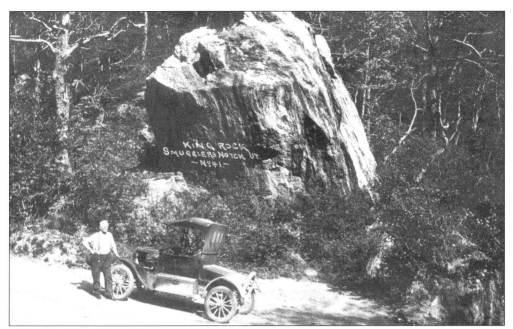

The road through Smugglers Notch could have barely been called a road until the summer of 1922, when it was officially opened after four years of improvements had been made. King Rock provided a great place to let the car rest.

The dark shape high in the cliffs shows the spot where King Rock fell from. Below is the path it cleared on its way to its place at the bottom.

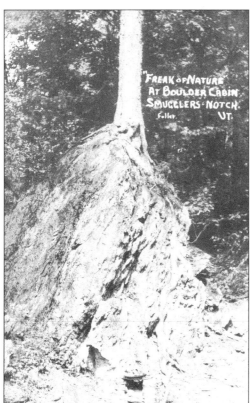

Extreme conditions prevail in Smugglers Notch, including those provided for this tree.

Smugglers Notch, the narrow, deep pass between Mount Mansfield and the Sterling Mountains, has been a source of wonder, challenge, and imagination since it was first visited. From the canyon floor, one can look up the rock cliff walls and spot a variety of rock formations aptly named, as is pointed out in this 1930s postcard.

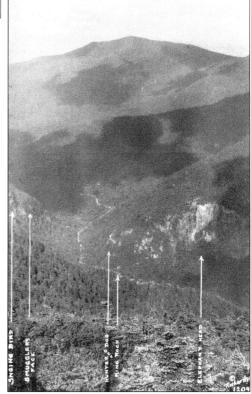